FOR THE RIGHT KIND OF LOVE

FOR THE RIGHT KIND OF LOVE

A Life Journey

SHARI MOSS

LIONCREST

PUBLISHING

FOR THE RIGHT KIND OF LOVE

A Life Journey

ISBN 978-1-5445-1840-4 *Hardcover*

978-1-5445-1839-8 *Paperback*

978-1-5445-1838-1 *Ebook*

978-1-5445-1841-1 *Audiobook*

To Suzy and to Wilma, with love and gratitude.

To McKernan, for everything.

And to Me.

CONTENTS

Part One

THE EARLY
YEARS

INTRODUCTION

SITTING ON THE FLOOR, LEGS CROSSED, THE SEARS catalog was open in front of me to the couch section. There it was, the perfect rust-colored sofa, facing the fireplace in a sunken living room with forest green carpet. To the right, and up a few steps—a glimpse of a dining table set. The large front door was just to the left with shiny golden walls around it. Next, I turned the pages for the best room, my bedroom. It would be my own room, exactly how I thought it should be. I can still picture it all to this day.

I was about nine years old. There were four of us siblings, sharing a single motel unit out in the middle of the desert with my mother and her second husband in another unit. In our room were two sets of bunk beds and one tiny dresser. Around a wall was an open closet with lots of shelves, occupied by a few clothes and a single board game of Monopoly. My stepfather owned the motel. None of us

liked him, none of us trusted him, but at that point we were too young to really know why.

Picture the Bates Motel on that lonely stretch of highway and you have the idea.

This was "home" for us. My brother was the oldest, then myself, and two younger sisters, all of us only a year apart. It was a good thing that there were four of us; we had each other to run around in the desert with. We didn't really have "toys." We were poor. A stigma then, even for California (at least in those parts anyway), but probably more so because it's basically human nature, which I came to learn later.

I went to school in the small town of Indio. We were bussed in. I remember the other girls had pretty dresses and "nice" ribbons in their hair. I sat in awe watching them, dreaming about the fabulous life they must have had. They had houses. *Real* homes. I went to sleep at night in wonderment of life in those homes. How perfect it all must be. They could actually say what they wanted for dinner!

I had gone once to a friend's house down the road about a mile. Believe me, we were very spread apart. I lived in La Quinta, a pretty dry, dusty town well outside of anything resembling a city. I went home after that visit marveling at how the brother and sister each got to say what they

wanted for dinner. I still remember that one said pizza, the other, Hamburger Helper. I never got to see if they got what they wanted. I probably didn't ask but, even more probably, wanted to. Funny, one of the first things I bought for groceries later as a teen when I had my first job was Hamburger Helper. It made me feel sick after having it a few times. I never ate it again. I wouldn't feed that to my dog today, but the sixties had just left, the decade where frozen TV dinners, canned vegetables, and sugared cereal made their way into everyday meals.

The house I designed for myself that day on the floor in that tiny motel room had the best little girl's room! It had white wooden furniture, thick, dark pink carpet, a pretty pink coverlet, and frilly white pillows on the bed. There was a bright window just behind it, and I can still see the white slatted door to the closet. There were toys scattered around, plush mostly, I think. I could picture myself walking up the stairs to the second floor of a house, and it was all mine.

DESERT MOTEL

THE YEAR I WAS NINE, AND BECOMING INCREASINGLY aware of what a poor life meant, my three siblings and I were invited by that "real family from down the road" as I thought of them, to go to the 7-Eleven on Halloween night. There is no trick-or-treating when the houses are that far apart, not to mention on a desert road with no lights. As we walked into the store, the parents of the two kids told us we could have one of *anything* in the store. "Anything," they said.

"Anything?" I said as I turned around and looked at them.

"Yes," the father said, smiling, with his arms spread out wide. "Anything you want. You can each pick one thing!"

My sisters and brother went right away to a front rack overflowing with fruity gum, candy bars, penny candy, and

such. Not me. No, I took a little stroll through the store, marveling at what was in the aisles. The store smelled of all its confections and, I was a very imaginative dreamer. I needed to inhale it. I stopped in front of the soda pop fridge. They haven't changed much since then. I looked up at the array of shiny bottles in all sorts of pretty colors. This was not something we had often in my world, trust me.

Everyone was waiting for me at the cash register, so I grabbed a bottle of soda. Not the personal size mind you, but the large one, the kind you could get four glasses out of. I hugged it all the way to the checkout. I don't remember exactly what kind it was, but I do know it was green, a somewhat electric color not exactly found in nature, as is the way with sugary liquid treats.

We went back to their house for our little party, one of very few I remember being part of as a child. The parents put my pop in the fridge after I poured a glass. When it was time to leave and we were at the door, I suddenly remembered it and went to go back to get it. The parents were standing at the doorway to the kitchen, blocking me.

"No, we will keep it here in our fridge," one of them told me.

Arms that were wide open before were now very closed and crossed across their bodies. Both of them were looking at me. I immediately understood.

"Oh, yes, then it'll be here for a glass when I get back," I said to them. Or something like that. I know I was trying to be casual about it. I likely missed a beat before I spoke, but I knew. "Or someone else can have a glass," I added and very quickly left.

What I learned that day was something that would come back to me time and time again later in life, and what would become an essential part of my core beliefs: what is right and what is good. I wondered then how they could choose to embarrass a little girl instead of owning up to what they said they would do.

What was the point of "looking" like a hero and not actually *being* one?

I was smart enough and just tough enough to know what had happened. And I thought it was wrong. I certainly would have been too embarrassed to tell anyone in my home, if there was anyone to tell, so I kept that story locked inside of me.

I hid my lunch when I ate at school. We each had a soft plastic lunch box that we'd eat from once we turned it on its side, with the top flap laid on the table. I leaned into mine while I was eating because I thought I had a "poor" lunch. The kids at school were not as bad as the teachers when it came to treating me differently. Kids are

kids, they just want to play, and this was an age where the opinions of the parents weren't quite trickling down. There can be bullies at any age and any era, so that stuff was probably just life. Yet, I know I was treated differently by the teachers through little things such as not being given the same advantages, attention, or caring for that matter. What I never understood, though, was how they could do that, based on something that was out of my control. I was nine. How could I go shop for new shoes? I couldn't drive! I was nine. How could I make my lunch and actually have a drink to go with it when we went on day field trips, if there was none to pack? Why was no one concerned?!

I have a feeling that I somehow figured out then that I was going to have to do it myself. Whatever "it" was. Neither of the parents were around much, either.

There was one woman that meant something to me in those days. Her name was Vera. We called her Aunt Vera, and she cared. Vera was a cute, round older woman with short white hair. She wore those long house dresses you drape yourselves head to toe in and was always carrying one of her two fluffy, white poodles. Vera had a wonderful house down the road a mile or two from us, Spanish style. I remember there were tangerine, orange, and lemon trees on one side of her yard and a huge pomegranate tree hanging over the fence from her neighbor on the other

side. It seemed magical to me, and we picked the fruit when we could.

What I remember most about our time with Vera was the Christmas we spent with her, all dressed up pretty, and taking a picture with her by the white fireplace and big Christmas tree. The food was plentiful and delicious: thick slices of juicy watermelon and the best sandwiches, tuna and egg salad mixed! My paper bag lunches were very full when we stayed there a couple months later while our baby sister was born, the fifth addition to the motel unit.

I was in grade four, and the school play at Christmastime was *The Peanuts Gang* by Charles Schultz. Lucky me, I was chosen to play Lucy, an important role. I know it's because I pretty much looked like her, small with nice, shiny dark hair and brown eyes. I learned my few lines very well, and I wanted to make this special for my classroom since we were chosen to do the play. I hadn't had great opportunities to shine in my class, although I knew I was smart enough.

One day, my teacher put the word salmon on the board and asked us all to whisper into her ear how it was pronounced. As she went around the room, I was so happy and sat confidently because I knew the right way to say it. When she had finished going around the whole class, she sat at her desk and announced that only one of us had

gotten it right. Most had pronounced the L, I was sure. I swelled with pride.

"The one who said it correctly, would you please stand up?" she said to us, smiling.

I stood up. So did one other girl. I just sort of smiled at the teacher and at the other girl, thinking that she must *think* she got it right.

"Shari, please sit down," the teacher said as she looked at me sadly. "It wasn't you."

Confused, and actually standing up for myself for once, I told her I knew how to say it. She again told me to sit. I stood my ground.

"It's salmon," I said pointing at the board (without pronouncing the L, of course).

"No. You didn't say it correctly," my teacher replied, now glaring at me.

At this point, no one had actually said it out loud yet. The other girl with the "nice" ribbons and the pretty little dress stood tall and smiling and I had to sit. I honestly wondered why the teacher didn't catch or at least acknowledge that I said it right just then, before anyone said the word out

loud. Was she just going to cover for herself making a mistake? One of those moments I never forgot.

So, as I am being honored with the role of Lucy, I am not going to let my teacher down, or the kids in our class. Boy, did I practice! I mean, I probably had what, four or five lines? Still, I was simply going to be the best Lucy.

The play was to be at seven o'clock in the evening at our school, the night before our last day before the Christmas break. My sisters, brother, and I went home from school on the bus, had something we could find to eat, and then we just talked together. I paced in the one room we shared as our bedroom and, really, the only room we had to use most of the time. My mother and stepfather weren't home.

Just before five o'clock, I started to watch out of the screen door of our room for them to arrive. It was the desert and it was going to be dusk soon (when you don't want to be around the huge flying things). I stayed on my side of the screen and listened for the car, for the crunch of gravel. The cars were boats then, literally, and could be well heard. I never moved, just stood staring out of the screen door. I was dressed, washed up, and ready.

By five-thirty in the evening, it was getting dark and I was beginning to get nervous. I kept leaning out of the doorway, but...nothing.

By six o'clock, I was trying to calculate in my head if we could still make it in time if they showed up. My sisters and brother were all anxious for me and tried to cheer me up. There was still time to make it, they were sure, although two of them didn't really know.

At six-thirty, I was losing hope fast. My brother was keeping tabs on the time for me so I could be ready to bolt out the door and into the car.

At six-forty-five, I knew it wasn't going to happen. I pictured all of the other kids in the play backstage, and, especially my teacher, waiting. Being let down, I was imagining what they would do. I know I didn't want to cry, but I also know I must have.

I never turned away from the screen until seven o'clock. I stood there the whole time. My parents didn't come home. As I turned around from the door, they all just looked at me. Then, my brother spoke up.

"Do the play for us," he said. "Tell us the play, and do your lines."

I did. The three of them sat in front of me like an audience and I did the play for them. My youngest sibling was about seven and seemed to really like it.

The next day, I went straight to my teacher. The other kids from the play were with her as well, as we were to put it on again for the school at lunchtime. It was a brand-new school with a nice auditorium and a big stage. Grades one to six, I think. I remember she turned around and laid right into me. The look on her face! She demanded to know how could I have let them all down like that. If she could have spit, I'm sure she would have. At least, that's how I remember it. The one boy who played Charlie Brown was literally glaring at me. I tried to tell the teacher what happened, but she wouldn't let me. All I could think for a very long time after was: "I can't drive! I'm nine! How was I supposed to get there?" When my teacher walked away, Charlie Brown told me, very angrily, that I had really made a mess and they had to get someone else just before the play. The gist of it was it didn't exactly go well with her.

I'm not sure which hurt me more, it coming from the teacher or from Charlie Brown.

Just around lunch time, the last order of the day before Christmas break, we all went to the auditorium. My class was there ahead of the rest and getting ready to perform. I stepped up for my role as Lucy and my teacher marched right over to me on the stage.

"Oh, no, you don't! You don't get to be Lucy today. You didn't bother to show up last night," she declared.

I actually remember those exact words fairly well. She then pushed another girl forward that was going to take my place again. The other girl didn't say anything and was rather shy about it, quite sheepishly looking down. My teacher then pointed to the reindeer row where the rest of my class, with reindeer horns atop their heads, were seated in a row on the floor along the front.

"Grab a tambourine, you're down there," she said as she turned away.

I grabbed a tambourine, our sleigh bells for the play, and took my place below the stage. The whole time I was trying to sit up a bit and turn around to look at the show on the stage while it was going on. Another teacher had to tell me to stop and pushed me back down.

I didn't get to have the cookies and punch in our classroom after, as I spent it in the bathroom by myself taking care of a tremendous nose bleed. I never did tell my mother what had happened, and there was certainly never any point telling my stepfather unless you wanted to be made fun of.

Lucky for me, we moved to a different city for my next school, grade five. Las Vegas, with a newborn sister and my stepdad, a liquor salesman. Las Vegas, where I narrowly missed being called out to a fight after school by someone I didn't even know.

LAS VEGAS HOME

GRADE FIVE. NEW SCHOOL. VEGAS AT THAT TIME probably had a population of about 100,000, maybe 200,000 at the most. The "old strip" was intact and still a very cool place. This was the time when the mob still owned the city. People won and there was excitement in the air: shouts, bright flashing crazy noises, and heady laughter. There was no crime. They saw to that, quite effectively. Tourists had to feel safe bringing the money they poured into the machines and tables. They were handing it over, just in a different way. And, the women! Dolled up. Hair always "done," bright beautiful sexy dresses and heels, lavish earnings, and full makeup. It was an age of sensuality and decadence, from the shows to the dining rooms, to the magnificent lights.

Slot machines lined the wall along the windows after checkouts in grocery stores. The Jerry Lewis Telethon in

September was a big deal for the city, and we watched it live. We spent two years living there. The first year was in a house, small and plain, with dirt for a backyard, but in a little neighborhood where we could walk to school and see lots of other kids around us. There was a public pool around a corner where we spent a lot of time. I'm not sure why I actually remember the path to school, but I do. I looked it up on Google Maps many years later. Without knowing the name of our street, only the name of the school, I saw the house we lived in as I followed the path down from the school. I still remember all of the names of my schools, and there were plenty. I never attended one for more than two years from kindergarten to the start of high school. Eight schools, in five homes, in four cities, in two countries, from kindergarten to grade eight.

Just like the Desert Motel, there was no trick-or-treating in the Vegas Home; this was where razors in apples were born.

I knew I was smart, intuitively or simply from observation perhaps, attending the first school in Vegas at the age of ten. I was sitting in a circle in my classroom, at the start of the year, and the teacher passed a book around asking each of us to read the next paragraph. As the other kids were reading, I stopped and looked up at them, and then at the teacher. I simply couldn't believe how slow they were reading and how they struggled with it! When it was my turn, I breezed through it.

A couple of weeks later, beginning our school day the way we always did, we were all lined up outside on the tarmac in rows of classrooms. The song with the line: "and those caissons go rolling along" was playing on the loud speaker. Incredibly, that line comes up for me in my mind at the oddest times. That day, it most likely followed the National Anthem. After that, the lines began to move, or rather "march" to the appropriate classroom. On this particular day, my teacher walked up to me in my place in line and asked if I thought the class was too easy. Gratefully, I nodded. She said I was going to be put in the next level class. I remember breathing deeply and standing even taller in that line while that song was playing and feeling such a proud moment for myself.

The school had two levels for each grade, the regular and the advanced. I was moving to the advanced class! My mother had put me in the regular class, I was sure of that. It wasn't the school that did, because my older brother started in the advanced class of his grade.

Just because we had a house did not mean we had food. Or enough of it. I was hungry. They had a program at my school to give a lunch to kids in need. We ate outside (this was still the desert) on a cement pad with rows of picnic tables and a roof over top. I think it was hotter there than in California to be honest. There was a long table set up at lunchtime on one side with some ladies (probably volun-

teer moms) standing behind a row of paper bag lunches. The bags looked pretty full to me. I walked up one day, and a lady smiled and handed me one. Wow, how easy this is, I thought to myself! It was a lot of lunch. The next day, I went up again, but the woman asked my name first.

"Sorry, you're not on the list," she said as she looked at her papers. It wasn't in a mean way but rather disappointed. I was very slim, bony you might have called me.

I eventually asked my stepdad for a nickel every day to get a carton of milk, but I saved it and every other day I got a push-up ice cream for a dime. As an adult who has taken it upon herself to help feed hungry children, I did later wonder about the kid who didn't actually get a lunch that day I got a free one. It stuck in my mind that at least I had a sandwich in my own bag, even if it was Spam on white bread, and they probably had none. When my son got to high school, he was known among his friends as the one who always offered to share his lunch, or money for lunch, with whoever had none. It's one of the most important things I instilled in my children.

But, at that time, I was ten, very skinny and growing, and I was *hungry*. The classroom doors were all outside, down long hallways. We were supposed to put our lunch boxes and any paper bag lunches not finished along the edge of the sidewalk by the class door before going to the yard

to play. As I walked along those rows when no one was around, I had an idea and began to swoop up a paper bag lunch while going by. I'd turn the corner, look inside, usually found some sort of treat which I would eat, and throw the bag away. If it wasn't of particular interest (I had enough baloney in my life) I would just drop it back. I'm not sure how long it lasted before they assigned a student from each class daily to stand guard by the door and the lunches, but there was an announcement not too long after. Drats! Foiled!

Then, one day, a girl from my class that I was becoming friends with asked if she could put the rest of her bag of Doritos in my lunch box. I let her of course, then later walked quite confidently up to our "sentry," opened MY lunchbox, and walked away with the Doritos. I was sitting beside her in class, as she started complaining about her chips being stolen and wanted to tell the teacher. I convinced her not to; I very well remember asking her not to as I feigned exasperation.

"I just don't want to hear another lesson or hear her go on about it. I just want to get to work," I said to my friend.

She stared at me and did not tell the teacher, but I don't recall any association with her after. I'm sure she knew. After all, it was the *advanced* class.

At the end of that school year, two things happened. The

first was I got invited by the girl across the street to her birthday party. All I remember besides a big group of us playing in her yard with a whole lot of swings and stuff was the mother giving me a hot look and then feeling very embarrassed by the gift I had given: a cheap coloring book and a box of crayons. At least it was the sixty-four pack. I stood under her glare wondering how it was my fault. I wasn't in control of what we could give her. I couldn't shop for it. I didn't have money. Hell, I didn't even have enough to eat.

Instinctively, I knew that I was enjoying lots of treats and fun, and my gift simply was not enough (compared to all the things the other kids gave). Was I ever going to fit in? Was anyone going to accept me for who I was and not be concerned about things that were out of my control? I'm pretty sure it was then that I designed HOW my life was going to be in my future. I already had the house imagined. Next, it was on to what I COULD do. At this point, all I knew for sure was there was going to be lots of chocolate pudding in my house.

Then another thing happened. We moved again. Thank goodness. The year I went into grade six, the City of Las Vegas, which was growing at a very fast pace, became over-crowded in the public grade schools. Officials decided to take the last grade, the whole of the sixth graders, and put them all in one school. We would be bussed and gath-

ered together. The only problem was that it was the school smack dab in the middle of the poorest, and I do mean poorest, part of town. It was what we would call the ghetto, but the real kind of its namesake, not what the young people today think of. And it was pretty much an all-Black area. The sixties weren't that far in the rearview mirror and were still very much a 'thing' to our parents. My parents considered changing me to a Catholic school, but that would have cost money for a uniform. So, off I went, to the bad part of town where the bus took me every morning.

Turned out it was one of the best years in school and for friends I ever had, the stories I made up for them notwithstanding. It wasn't the boys I needed to be afraid of; it was the girls from in and around that neighborhood. You wanna talk about tough? Tough like you don't even know. Us other girls kept respect abounding for them, and clear boundaries, but the guys were happy we were there and kept watch over us.

But what happens when you are in a large group of kids all the same age—the same age of interests—from what you like to wear, play, read, or watch? Well, you end up with an entire population of like-minded people in a very special way. It's easy to get close and easy to get along aside from the normal jealousy that erupts. Even with the established, unspoken-yet-clearly-there "hierarchy," for the most part, we all got along. Of course, me telling whopping stories to get the right kind of attention didn't hurt either.

Patty, Susan, Donna, and a few others—all those glorious names that rarely get used anymore and have become criticism fodder for the endless memes today—they were my friends. Sandra was on my bus and we lived near each other. It was nice to have someone to talk to on those long rides home. Those four are just the names I still remember; all four of us were as different as could be. They knew I came from California and were very curious about it. I told them I was in a movie (probably said movies: plural). I particularly embellished that we got to keep the clothes we wore in the film and said that was the best part for me. I even described those great clothes, the likes of which I'd never seen. It was wonderful basking in their attention, but mostly I think their curiosity. I got to talk on and on, and, boy, was I good at telling stories, so it seemed.

It turned out we all *loved* going to the school our parents were so afraid of sending us to. It became one of those groups, or atmospheres, like you see in those prison movies or teenage traumas that end with the respectability born of going through situations together, banding together when everyone else was an outsider. I was skinny, wore glasses, and had hairy legs, but I was no outsider. I was smart and I was doing well. But I knew *how*. I had my thing. It was abounding with my growing imagination, stretching my limits by getting into a bit of trouble, and feeling like I was not invisible in my classes or in the school yard.

To get to the school, we drove through the worst streets: crack houses, prostitutes, and garbage were everywhere. Old men smoked on the stoop with cigarette butts hanging out of their mouths while babies ran around them in sloshy diapers. And yet, it was the most memorable year, the most I fit in of any school year. We all fit in, even the pretty girls with pretty dresses and "nice" ribbons in their hair. They accepted who I was, albeit a slightly skewed version, even the mean girls, and I, them. And I was not the only one who sometimes had a shitty lunch or was hungry. Many of us were.

At the end of the year, pretty much all of the kids in my school boarded several busses at six o'clock one morning, rode the few hours to Disneyland for the day, and then back in the evening. The bus cost ten dollars and the day's book of tickets for the park was five for a round trip for fifteen dollars total. Lucky me, my parents were willing to let me go. It was nip and tuck for a while, but I got on that bus.

What a day we had! We were let loose on that fabulous playground, everyone the same age, everyone we just spent nine months with inside classrooms. We ran, played, laughed, and ate candy, and for the first time I was free to spend it with no parents, teachers, or elders. That was one of the best days I ever had, and I will never forget it. I was an equal, I had a ticket book just like everyone else.

I had a lunch bag for the bus just like everyone else. I had a seat on the bus just like everyone else. There was no drama between the kids, none of the stuff that brews or comes bubbling up, just true fun. It was too precious of a day to waste not having a great time together.

We bought five-cent candy sticks, flavored hardened sugar really, that were stacked up in a hundred beautiful colors it seemed. These kept us going all day after such an early call. No one had slept on the bus ride in.

I left that school at the end of the year kind of different I suppose. Perhaps it was that I hit an age, hit a level of knowing, a level of something that I was growing into. I never saw any of those girls again, but it didn't matter. I had created an image of myself that I was happy to leave them with. On the last day of school, my mother told me she was sending my brother and I off to live with my real dad in Pennsylvania for the summer. My brother did not get along with my stepdad. In fact, we all hated him and thought he was a shithead, but he was a different kind of hard on my brother. My mother was worried that he wouldn't come back from our dad's, so she sent me, too, and off we went.

I didn't know my father; our parents were apart since I was four. I do have very early memories of him, and I feel like they were good and that he was a kind, simple man

or maybe I'm projecting something I came to learn later. He was the reason we got to California in the first place, for his work, and now he was remarried to a woman who had three kids, living in suburbia in Pittsburgh.

The "summer" turned into a whole year, June to June. It was my first taste of what it was like to live in that kind of "house," a family house with grass and a winter season, in a family neighborhood with all kinds of cool things like ordering a pizza for delivery and trick-or-treating. There were housewives on the porch trading gossip, Avon, and adult dinner parties. As kids, we ate too much, because there WAS so much at those parties, until we threw up. It was my entry into junior high including all of its trials and tribulations and my first bra. It was another year of discovery, but a year to learn that it was still not where I belonged. It was merely a glimpse of what that kind of life was and what I wanted to have someday.

I did not want to stay, so when my mom moved back to Canada to her family without my stepdad after catching him cheating, she came to get my brother and I. I was happy to go. I wanted to be in a land with grandparents, aunts, uncles, and cousins and things I was starved for living all of those years out in the desert. I needed it and it was just the right coming-of-age time for it. I was certainly not attached to anything or anyone from the previous years. So, there we landed, in a small town in Northern

Ontario, Canada surrounded by family. No drunk stepdad, just us.

I was thirteen and on to my next school and my next set of new friends, in a very small school right across the street that I could walk to. And start over.

CHEAP RENTALS

WE WERE FIVE GIRLS, VERY CLOSE FRIENDS IN OUR high school years, during grades ten to thirteen. All of us were different, all of us were fun, none of us were without the usual teen angst. We were essentially good girls, aside from the usual sneaking of underage drinking at the park or having parties that started, literally, before parents were even off the street on their way to a week's vacation. The things we shared, the dreams we had, the boyfriends we wanted, was nothing unusual. Although for me it was a little different.

There were five of us siblings then, living in a small unit of low-income housing and our single mom was nowhere to be found. This was not unusual. As a matter of fact, we were better off when she wasn't flying in the door, being disgusted and mean because "her" house was in shambles or "her" youngest was not being properly looked after.

Four of us were teens, but my younger sister was ten years younger and in early grade school. The teens that we were weren't exactly excited about having to be home for her on our precious social weekends. But we had to and spent time between us negotiating whose turn it was and when. My resentment for my mother turned into resentment for being in the situation. I am sure my seven- or eight-year-old old sister felt it. At the time, I never gave that a concern. Life was going to move without me, and I did not want to miss out on it.

Whatever I thought of my mother before that time only became much worse. She had had four kids under the age of five by the time she was twenty-one. But what did that mean to us? She had made no bones about the fact that she hadn't wanted any of us. We all just kept coming along until the last of the four of us with my dad, and then our younger sister with our stepdad. Anyway, by the time we moved back to her hometown in Canada and got settled there, off she went to do all the things she clearly had not had the chance to do. We were left with the care of the house and the youngest and the necessities of daily life for ourselves.

My mother took art classes at college, hooked up with younger men, and disappeared for a week or so at a time. She did not support us in any way, it certainly felt. She took money from an older man she was visiting on the

outskirts of town, but mostly if we wanted to eat, we had to have jobs. We all worked part time as soon as we could. With that came disposable income, which we used to buy clothes, go out with friends to hockey games, and get french fries afterward at the diner.

Sadly, she'd take our money. She would come into our rooms in the morning and sneak into our wallets. I woke up once to see her in my purse.

"I need this more than you," she said as she looked up at me. "It's for the house." Maybe it did pay the electricity bill, but off she would go, out again.

My sister, the middle child, one year younger than I, bore the brunt of our mother's moods. Yes, *The Brady Bunch* episode of middle Jan rang very true for her, it seemed to us. I will never forget how my mother used a hanger to beat my sister because of how much she had spent on the latest fashion of jeans. My sister had bought them with her own money she had worked for. It was a hanger, not the belt she usually used on us. Humiliating is all I can call it. Mother (I've never called her "Mom") walked into the house one day after an absence, heard from my youngest sister how we didn't treat her properly, and there was some other "infraction" like the bathroom hadn't been cleaned. Without discussion, she lined up the three of us teenage girls at the end of our beds, told us to bend over, and hit us

all several times each across our butts with a leather belt. She only did it to us three. She never touched my brother, the oldest. I knew one day that she was not going to be able to do this to me, but I also felt helpless at that moment, as if I had no control over not allowing this to happen. I absolutely knew for certain I was never going to treat my own kids that way. I just had to get through school and make some money before I could get out.

Then there were the threats from my mother. I don't remember what they were for, just that words like, "I'll cut your hand off," came out. I remember my frustration the one time I told my friends. I opened up about having the feeling that she meant it; they just laughed. It was rare for me to get so emotional about life at home. I preferred to just forget it when I was away. Normally, I would be like I was supposed to be, nattering with the other girls about boys and teachers and clothes, but I'm not sure if they just didn't get it or didn't want to. More than that, I felt incredibly sorry for my very young sister. I was simply trapped in a sixteen- to nineteen-year-old's mind. I worried about her. I just didn't know how to deal with it.

I was tough. I had to be. There was no choice. I was the one who took the dare to go to the liquor store underage to buy beer for the five of us friends. Shit, that was nothing to me. Which is probably why I got away with it, too. It's also why I had no trouble talking to boys and ended

up being the one with a couple of boyfriends during high school. It was nice and something just for me, something I was in control of and could just be myself with. I never dumped my life stuff on them. I just enjoyed being with them, at least for the most part.

What was somehow worse for me, and terribly confusing, was how the other parents treated me. I understood very, very well it was because of my living circumstances: no parent around and the housing we lived in. What I failed to understand, once again, was how they could judge me for things out of my control. I was no different in terms of knowing right from wrong and good from bad. I was just like the rest of my girlfriends in the excitement and silliness of being teenagers but also having responsibilities and going to school. I don't necessarily think it was ALL the parents of the other four. After all, it WAS well into the seventies and we were pretty free and easy in those days, the polar opposite of today's "Umbrella Parent."

I suppose that answers the question of why they didn't have a conversation about my circumstances, ask how I was doing, offer me dinner...something. This, to me now, clearly explains why I have spent a lot of my adult years helping kids in my own home, in many respects.

There was, however, one mom that I particularly liked or even loved (if I was capable of such an emotion, then).

She was the mom of the one I considered as my best friend out of the four of them. Her name was Dorothy. They may have called her Dotty. She worked at Sears, in the ladies' department. She was cute and funny and she licked her finger to get all the toast crumbs off of the table to eat. She wrote everyone's initials on the paper lunch bags she lined up in the fridge, even for her husband. The others in my group thought it was cute. To me, that meant she must have made them different—THAT level of caring. When we took the bus into old downtown, we'd stop to see her at work and she'd give us coins to go get a treat.

Dorothy took me with them once when she drove my friend into Michigan to do back-to-school shopping, and we spent the night in a hotel. I was so lucky to have been able to go with them. It was the smallest thing maybe to others, but it meant *everything* to me. This mom was the one who actually asked me my opinions. It made me feel like I was alive. I counted. I felt like my real life was very far away and I was free.

I survived academically. I know for a fact I could have done much better in school, but I was hungry and I had responsibilities for things at home. It was just a good thing I was smart enough to get good grades without trying. I had a job when I was sixteen working at a Country Style Donuts coffee shop. It was on weekends, rotating the eight to four, four to midnight, or midnight to eight. The owners, two

Greek brothers, did the baking onsite during the graveyard shift as we called it.

One night, somewhere in the dead hour between three o'clock and four o'clock in the morning, one of them, the skinny greasy one as I called him, came out to the other side of the counter from me and laid down across three of the counter stools. He looked up at me with quite a lascivious smile (seems like the perfect word for it), licked his lips, and was rubbing his lower abdomen...or thereabouts. He didn't know I could see him in the reflection of the window behind him. I didn't react and tried to keep myself busy cleaning.

The next night, he asked me to help bring the garbage outside at the back of the building. The door closed behind us and he grabbed me and essentially stuck his tongue down my throat and tried to feel me up. That's what I remember. I know I broke free and went back in and said nothing. There was a "head" waitress, the scheduler, an older woman living alone, that came in to take over at eight. I tried to tell her what happened, but she kept walking away busying herself with her purse and stuff. Even at that age, I knew. I knew she needed the job and the position and I was not going to change that, not risk it. I semi recall her asking first if perhaps I was a little mistaken. Her walking away and not commenting or helping was when I became adamant with her that it did happen. It's

not like I could tell my mom who wasn't there. God only knew what her reaction would be. I won't speculate, but I have a good idea.

I ended up telling my boyfriend at the time. A straight-up dude, mature like me, he was my first boyfriend and I still remember with fondness the brief time we dated. Subsequently, he showed up the next time I had to work that shift. He came in the middle of the night and sat at the counter talking to me and drinking coffee and eating donuts. He came by himself, not even with any from his great group of friends. The owners were in full view on the other side of a glass window behind me, and they clearly got the message. I was never bothered again. Warren, you dear soul, wherever you are, thank you from the bottom of my heart. I didn't stay there much longer, off to Smitty's Pancake House next.

Graduation came. It was a full-on fun affair. By that time, we were in our fifth year together and the whole grade was a small, very tight group. Being nineteen that year was also important. We could celebrate at the local watering hole. But typically we didn't do much of that; we loved hanging out at each other's houses for social.

It was graduation day, an afternoon in the high school gym. There I was in my brand-new dress and high heels I was so proud of affording.

"You didn't really want me to go anyway, did you?" my mother said to me earlier that morning. She was explaining she wasn't going to be there. She was actually home.

"No, that's OK," I said shrugging it off.

I was excited and actually didn't think too much about it. It didn't seem odd; she really hadn't been that much a part of my life, except to show up every once in a while, criticize choices and complain about what we were not doing. Off I went on my own. And it was lovely.

At some point, I am not sure when, but I think it was while I was sitting in my place, I realized I was the only one without someone there that day. No "someone" taking photos or hugging or shaking hands or congratulating—you know the drill. As I looked around at all the other kids after the ceremony, doing their duty with the moms smearing lipstick on their cheeks or the dads slapping backs, I had to wait for everyone to be done. That moment, that moment right there, never left me. It stayed stuck inside me for a very, very long time. It was not pity. I never wasted time feeling sorry for myself and I think that was the moment I also didn't want anyone feeling sorry for me. This, this is perhaps the moment of the determination, or ability even, to not show emotions. Tied, inextricably, to the *not* wanting of pity.

I was going to be moving forward into my life on my own.

I was nineteen and heading off to University soon (they gave away educations at the time, I received a grant and everyone got in) and was going to be in control of things. I didn't have to live at home anymore. I could sleep in on weekends. I only had to feed myself. I could make new friends and hang out where, when, and for however long I wanted. The fellow students would be alone, too, not at home with family, and likely going to be on a budget for supplies and food and entertainment as well. I was going to be free. Good luck to me.

I left one night in September. I had a ride to University with a relative, a ten-hour drive away. With just a suitcase of a few clothes, nothing more, I was heading to a strange city with not even a place to stay yet. But I was tough, a survivor, and this did not scare me but a little. As we pulled away in the evening, about to drive through the night, my nine-year-old sister was the only one home. She should not have been left alone there, really. I remember talking straight up to her on my bended knees, urgently, looking her in the eyes with my hands on her shoulders, and telling her to be very quiet and stay in her room. I made sure she knew to not answer the door or phone. Then, I left, crying silently for the first couple hours of the drive.

I knew a girl I had met through a church group event that lived in the city I landed in for school. She was leaving her city to go to her own out-of-town university but was home

for one day still when I got there. I don't remember this nice girl's name, but she took me in, as long as I needed (according to her) and let me stay in her room with her the night. On campus, I had to register alone. It did not get by me, the multitude of parents on campus that week; I still marvel at movies that show this. I set up my banking after picking up my grant funds and endeavored to find a place to stay. My friend left town the next day. Her house, I absolutely loved. I could probably still find her street and I haven't been near to that city in many, many years. But I also remember her mom. It was the final defining moment for me in how I became determined about my future, what I knew was going to be important. And I was beginning to form ways of making my own statements.

I had to be there for a couple more days. Her mom did not even speak to me, period. Nothing, not a word. When I was there, I just sat for hours on end in my friend's room. One afternoon, I could smell food cooking and bread toasting so, eventually and slowly, I ventured downstairs and into the kitchen. The mom was sitting at the table eating soup. She said not a word but did look up at me once when I walked in, with a very sour face I recall quite vividly. After making a preamble of just getting a glass of water, I had no choice but to turn and walk back upstairs. Not for the first time, not for the third time even, I thought to myself what is it with these parents? If we had the terminology back then, it would have been WTF?! How could anyone

do that to someone? I swore to God that day that I would never behave that way. What did I ever do? Couldn't she see that I was all alone and feeling strange? Not to mention I was trying to respect her and her space. I wasn't exactly being bold and strange and feeling entitled to anything. I swore I would never *not* share my food. Ever. It was just too cruel. If I ever had any.

I found a small cheap upstairs apartment of a house nearby to rent, slightly furnished. I had no blankets or towels or anything for the bed and bathroom, but there were a few dishes. Before my friend left, she told her mom she was going to give me a couple of things they had. There was a quilt that was clearly buried somewhere forgotten and well used, it certainly wasn't entirely clean, and an old itchy blanket. I took it gratefully.

But, as I said, I was learning many things and my dignity was one of them. If they were going to make a point, well so would I. If they were going to judge me without knowing who I really was on the inside, well I was going to show them. Eventually, my grandmother handed down to me a big bag of towels and sheets and a couple of blankets, which I picked up from her when I went home for Thanksgiving. I then hand washed that damn borrowed quilt and itchy blanket in my kitchen sink with lots of soap and elbow grease. The water really was quite dirty brown after, as I suspected it would be. After they had

hung to dry, I nicely folded them into a pretty bundle of now brighter colors, and walked over to that friend's house, carrying them.

On the porch, I rang the bell. I can see that moment very clearly. The mom opened the screen. I held out the bundle to her, said thank you, and told her I had washed them for her. She stood there with her mouth hanging open as I turned and walked away.

Welcome to adulthood. My way.

MARRIAGE HOMES

A SEMI LIFE

I MOVED IN WITH THE FIRST MAN WHO CAME ALONG and said he would take care of me. He told me no one would ever love me the way he did. But it was his definition of "love" that I needed to learn. And he had a house! It was a very cute home, a semi-detached in a simple quiet neighborhood, with a small pool in the backyard. It was a bedroom community outside of the greater Toronto area. I had made my way down to Southern Ontario, out of the small steel town my family was living in, after an unsuccessful attempt at University.

With no support behind me, emotionally, mentally or financially, I just couldn't seem to make it through my first year away at University. It was hard to be motivated and I felt very alone. Yes, I had a couple of friends there and would visit with them, but they had their shit together, or so it seemed to me. They had parents that checked on

them and made sure they had enough money for important things like food. When the bus strike happened, arrangements were made for them to get a vehicle to use. This was just so foreign to me, to not have to try and figure it out on your own.

It wasn't in me to whine about my situation. I more or less shut down internally and spent a great deal of time sleeping in and skipping classes. That sort of thing will always catch up with you and soon I was unable to make up for all of the lost time at school, including missing final exams. Naturally, I hid that from my friends. I see now the plenty of excuses made, but I simply felt too alone and uninspired at the time. But the day I spent twenty-four hours on one can of tomato soup that I borrowed from the two girls living downstairs from me was the day I made changes. I was renting the upstairs space in an old tiny semi-detached house we shared. It was south of the tracks, the poorer part of town, right across from a massive brewery that spewed out the nasty flat yeasty smell of hops daily. It was time to go to work instead, to support myself, to earn an income and move myself forward. If the option to go back to school came up later, fine. Two years, two jobs waitressing, and part-time college later, I met the man who said he would love and take care of me, the man with the cute semi.

We were young; I had moved in with him at the age of

twenty-three. It was the eighties. It was the beginnings of Gen X: used to doing things on our own, forging our own way, jumping into living with someone out of both economics and the fact we did NOT stay long, living at home. There was money and work and opportunity to be had, and my generation was going to grab it for ourselves! We spawned weekend-long Euchre tournaments in college. Gamers today got nothing on us. The only difference was we did it in person, three days going by without showering, drinking beer, smokin' doobs, and eating out of day-old pizza boxes. Yes, he and I were ready to set up shop together, so to speak, and I found my opportunity.

Mr. Semi was over-opinionated, working full time and on a set track the way his life was going to roll. It was a very old-fashioned version of life, like his mindset was in the sixties while living in the eighties. But, oh, the house. Cute, back-split, two bedrooms upstairs, walk-out in the back to the pool with his minimal, with-the-times cool living room furniture. It was lovely, and we spent time wallpapering the kitchen, having friends over for late night card playing and snacks, afternoon swimming with BBQs... the real life. My old one was disappearing rapidly in the rearview mirror.

After spending our first year together working as a cashier in a neighborhood grocery store, all the time looking for a good opportunity, I got a job working in an office a mere

twenty-minute walk away. It was a good thing it was so close because he didn't let me drive his company car. There were plenty of young people working in the office, and I got a job handling the switchboard and various secretarial tasks. The pay was pretty entry level, too, but they let me in without experience, and it felt good to be believed in. It was a small, very fun office, and where I met the love of my life.

I was doing very well in my job. I was smart, quick, and moving up rapidly from a very entry-level position. Remember, I was in the "advanced class." But, according to Mr. Semi, it was not going to last. He very clearly let me know that I was going to have babies, stay home once I did, and live *behind* the white picket fence. My only identity was to be solely that. It makes me want to throw up today, which is what I did later even thinking about it all. Talk about not having a voice. Talk about dodging a bullet.

I didn't love him, I never did. I do realize that. But was it important at the time? No. Was the life he offered important? Yes. Did I begin to grow into my own power in those four years we were together? Absolutely. I was beginning to really know what I could be in control of and what I wanted to be in control of. Making my way into the world was still on my radar.

I hated my mother. I mean that succinctly.

Never mind all of the stupid stuff she pulled when we were young, I hated her for what she had wanted me to do. As the oldest girl (my older brother was exempt) I was, in no uncertain terms, to get a job right after high school and bring money into her household for everyone. I had gone to my aunt for help in getting her to realize I didn't want to do that and she had backed off.

My little sister, at the age of about fourteen, had come to visit Mr. Semi and I, in the cute little house with the pool. She and my mother had taken the long drive down and stayed with us a few days.

"I want to have a guy to take care of me, too!" my sister said to me, sitting on the couch in my living room.

I just simply stared at her for a moment, trying not to roll my eyes. I probably didn't succeed.

"Does he have a younger brother?!" she wanted to know.

"Yes," I answered nodding. "No," I then said, shaking my head. "I mean, yes he has a brother, but no! You are too young. And anyways."

I knew this was all from my mother. As a teen, I had been taught by my mom that people were for "using." Take what you could from them. Life was too hard as it was and if

you could offer something in return, fine. But it seemed to me that she also felt it was "entitlement" simply because they had, and she did not. Particularly from men. It was obvious in the way she was living her life and who she was nice to, but I knew that was not going to be MY way. I was going to build a work life and career and be able to bring to myself the things I needed, but mostly what I wanted. I was going to continue to work and still have fun. We were very social in those days in my youthful work environment, outings and such.

I was going to have my very own place for the first time. I could afford it. And in there would be all of the things I wanted to eat, who I wanted to share it with, what I wanted to watch on TV, who I wanted to watch it with, and for as long as I wanted. And so, it ended, my brief time living with this man in a lovely semi house. We became fully detached and thankfully I never saw him again. Yes, I did realize I hadn't ever been in love with him, but it was much later before I realized I did exactly what my mother had done.

FINDING LOVE

THEN, I FOUND LOVE. IT CAME IN A PACKAGE I WOULD never have believed. And it came when I wasn't looking, the best kind of love. He was working at the same small office as I. As a matter of fact, we started there within two weeks of each other. I was hired because they were growing; he was hired to turn the world upside down. He was young, hungry, smart, oh-so-charismatic, and came with lots of experience for someone so young. The owner of the small firm was in love with him, too, just in a different way.

It was a wire and cable distributor and before I bore you, I'll just say we stocked and sold reels of wire and cable to people who made everything from ambulances and transformers to toasters and telephone equipment. It was not an exciting business, but the office itself made up for that. All of us were young, and single enough. Maybe four in the sales room, two accounting, one in purchasing and a head

honcho who liked to party after work. Or during work, over long lunches with the guys while the girls took care of things. It was the eighties; everything you've heard is probably true. The way you took care of customer service was to treat the buyers to limos and strip joints with plenty to eat and drink, for many hours of the evening.

My husband, future at this point, was the best salesman in the industry and the best partier the office would see. He was wild, free, and driven and, to me at least, magical. I saw in him what I wanted to become. As it turned out I learned a great deal from him and ended up working under him in the sales department. Not only did we succeed there very well together, we began to realize who we were together personally. I had left the semi-detached man and I knew, I mean I REALLY knew in my heart that my life, my adventure, my path, my career was now laying in front of me. I knew I needed to grab it before it disappeared, before it was too late.

I had walked away from doing the wrong thing for me in order to do the right thing for my future. It hadn't been a hard decision. I had grown up. I had gotten myself a nice little apartment near where we worked, and I began to live, and learn about football. Mostly, I was in control. I was in control of my future, I was going to make the decisions, I was going to set up my little home and I loved every minute of the experience. It was not an old or run-down

place; it was a very nice apartment in a very nice building in a very nice neighborhood. I was so happy.

Happy until I woke up on Christmas morning all alone in my little apartment. I swore I would not ever wake up alone on that day of the year again. I had the life I wanted, but I needed it filled with love and hope and others. That much I knew. The day before, the morning of Christmas Eve, I had sat at my big picture window and watched my future husband drive away after spending the night with me. I knew that previous night how much I wanted to be with him. I did not know it was love at the time—that realization came a bit later—but I knew I wanted him. I wanted him so badly that I daydreamed about our life together. I Imagined how I would do crosswords on the couch while he watched his football games. How I would cook amazing meals while he worked because he literally was so dedicated that he worked six or seven days a week. How we would continue to make love the way we had that night. It wasn't our first time, but it was something with meaning. That morning after, I stared out of the window until his car was no longer in sight. Probably another five minutes after. It was amazing how I could lose hours wandering around my apartment thinking about him.

Strangely, when I first met him, I didn't see him as very attractive, but the truth was, as I saw it clearly once I was free—he was incredibly sexy, cool, and handsome. He was

also the consummate "bad boy" we all yearn for in our inner selves. I once explained to my daughter, who got caught up in one herself, that it's because we want to be the *one* they choose. And that's what also happened at the office where we worked. All the girls were in love with him, some wanted to sleep with him (hey, we were at that golden blossoming age), and I have to admit to enjoying the secret pleasure of knowing that I actually did get to be with him. He and I could not let anyone know. In those days, you were not allowed to fraternize. It may still be like that now, but this was in a bigger way. The boss was definitely not going to allow it. I felt that, in a strange way, he would be jealous, too.

So, we kept our "little affair" to ourselves and continued to each grow our careers through to the end of the decade. The company grew with additional staff, he was in charge of the whole sales department, and I had gone from the order desk to inside sales supervisor to outside sales, making calls on the road with him. We loved those days together, while our customers loved our dynamic and learned to trust us very much. Our clientele had gotten bigger, hospitals and telephone equipment companies and mining corporations to name a few. I loved my job, loved how good at it I was. When we had to go through the career book in the guidance counselor's office the last year of high school, an attempt to help us determine what college we should go to, I remember focusing on PR work. I also remember

my friends questioning that. Yet, here I was, sitting right in front of customers in a big industry, selling my wares. And doing very well. I still wasn't being paid much, but I knew this was the right track for me and still had much to learn.

My smart, sexy future husband had a falling-out with the boss and had to leave, and I followed very soon after. We had plans; we were going to set the industry on fire together as a team. I had absolutely no doubt we could and would. I skipped quite happily after him. He was hired immediately by a much larger firm, another cable distributor with branches across the county, and I went to work elsewhere temporarily until he was ready for me.

In the meantime, we were developing a deep personal relationship as well. I was still living in my apartment at that time. I will never forget the night I was sitting at his kitchen table in his little, barely-furnished townhouse. Don Henley was playing on a CD: "A New York Minute," his favorite, "Boys of Summer," and "All She Wants to Do Is Dance," loudly. Still favorites of mine to this day because it was one of those glorious memories you keep in your heart. He was singing, and it was one of my favorite things about him, how he could immerse himself that way, be so expressive, know what he wanted, and go get it. He stood up from the little out-of-date kitchen table he had taken from an older relative, untucked his white shirt, and held out the back of it to me.

"Hold on baby, 'cause we're going for a ride!" he said, and I was so in love with him right then and there.

I grabbed the back of his shirt and we hopped around his tiny living room like that, music and wine and laughing. I knew I would follow him all the way, follow him anywhere. It was one of the happiest moments of my life.

I moved in with him very shortly after. To us, we were husband and wife. We didn't need a piece of paper to tell us that. I still had a contract for my apartment, but I just left. I called them and said I didn't have a job so I couldn't pay, and that they may as well just rent it out and get their money, and here's the keys, etcetera, etcetera. They were stunned that I would just do that, but they did it. And I walked straight into my future. Work and play and love. Welcome to the nineties.

Success came in rapidly, but not in a million years did I think life would unfold the way it did.

WORK

MY HUSBAND AND I WERE AT THE DINING ROOM TABLE at his parents' house in another city down the road. We spent a lot of our time with them when we had some. At this point, we'd worked together for several years at the national firm. Under his direction with my own ambition, in-depth learning of the products, and a cultivated sense of style in sales, I had become the top salesperson in the company. With the modest salary came a great bonus structure as incentive, and my commission alone was enough to potentially buy a house. He was explaining all of this to them.

It was still very much a man's world and atmosphere, the business we were in, and I ran into challenges being head of the sales team and, eventually, across the country. I was brought to other offices to do some "teaching" about how best to sell to a particular group of clients. At one

such lesson, a group of about twenty had gathered in our Montreal office to spend an informative hour with me. The women were eager, sitting up at attention with pens at the ready as we are wont to do, the men more nonchalant. One young man in particular sat slouched with arms crossed on his chest and a smirk. Yeah, I know you, I thought to myself, but not today. I was me, this was easy, and too bad for him I long ago learned to stand up for myself. I immediately walked over to hold the door open.

"It is clear you're not going to be learning anything today, so you are excused," I said quite matter-of-factly.

He was pretty shocked, paused for a moment, but got up and left. I saw him through a big window having to explain himself to the owner of the company, the very one who had brought me in. I hid my happy dance in my mind. I vividly recall how the few women in the room smiled at me.

"Anyone else think they have nothing to learn here?" I said as my eyes swept the room. No reply as I watched the rest of the glassy-eyed students sit up a little straighter.

Sitting with both his parents that day at their house, my husband explained why we needed to borrow money, and how we would give it back to them in one year, in double. It was the extraordinary yet frightening pivotal moment of transition, from the exorbitant success we had as a

team while working for someone else, to having our own distribution business and taking our very high-profile customers with us. They included Nortel across North America, GE, Westinghouse, and others. But it was a very, very narrow window that had opened to us and these clients wanted to come with us. This was at the very cusp of wireless telecom (there's a heck of a lot of wire in wireless by the way) and we were poised to take it. I will afford you a peek at what came about, a future view: we did build our own company, we were incredibly successful, beyond even what we imagined. But in that beginning, getting started was going to take more capital than we had, although we had saved for years.

Needless to say, the parents said no. Furthermore, without getting into the specifics, they didn't believe we could do it. Never mind the great track record and years of success already. His parents were famous for saying: "You can't do that!" I heard it from them for years every time my husband said he was going to do something, usually around something big and great, successful and fun, and...sigh.

It really is no wonder he had so many issues inside that never resolved. I watched him spend years trying to make them proud, just to hear them say: "Great!" Just once. They eventually did, sort of, when we began paying for all their vacations and such. We covered a lot of "life" for them after our success. We worked hard enough to not have

much time for family in the early stages, so later we truly made up for it. But as confident as I was in business, due to a proven track record, not to mention burying myself in it, there was much I still needed to learn home-wise and family-wise. Particularly with having parents who knew everything about your life and played as big a role as my husband did. I mostly just listened, didn't say much, and just formed my own observations.

After that day at the dining room table, with our Big Ask and the equally Big No, we turned to someone else at the ready who DID believe in us. We eventually took him on as a business partner. He, of course, made some very big money from our hard work over the years while he was not part of the operation. There was no return-in-a-year agreement. He was a full partner, a silent partner as they are called.

My in-laws. Wow. They never did fully accept me while we were together, my husband and I. Such a shame, all of that wasted time being judgmental and just downright mean. I learned in time that it all stemmed from their own misery and alcoholism, but it was very rough going in the beginning years. I never understood how they couldn't see how dedicated I was to my husband and our business together, how much we loved each other. I really didn't understand how they could be so unhappy when they had so much.

He had a brother and parents that were still together and

they had a very nice house on a very nice street in a very nice neighborhood. How perfect I thought: a nice square family! Sunday dinners, Friday night cocktails, Christmas decorating and holiday fun, cabins at the lake...I don't know, just "things." Everything in their house was "just so" and it was all lovely. They cared very much about the appearance of it and was kept clean and tidy. But they drank, argued, and never really got along. I am not sure why his parents stayed together, but they clearly should not have. My husband was the black sheep, as I am in my family and, needless to say, there were some very challenging moments between us and them.

But mostly, what I have to say is how they did not "accept" me. I was not like them. They thought I was rough around the edges, brash, bold and different. Street smart if they could name it. This was actually a good thing to my husband and I, but they didn't understand. It was *those* qualities that you love about the heroes you have today—those outliers—the super successful entrepreneurs who now write all of those books and do those podcasts. You champion them for *those* qualities. But his parents were straight-from-Holland Dutch and I did not do things their way. End of the game before it began.

I did not know how to properly run a house, according to them, and they were correct. But how could I? Where would that learning have come from? For them, it was all

about how messy my dresser drawers were (if you could believe it), my towels not folded all nice-nice... How could I have drunk that good bottle of wine and used those good towels? The beds not made properly...ad nauseam. I kid not.

There I was, giving six days a week to the new business we created, taking care of my husband and I by cooking healthy, and still managing to cater to them when they came over, but my goodness my bed didn't look like a magazine cover. It was superficial, but I did try. What it really came down to for me, though, was that I never understood why they didn't just teach me? I didn't have parents to do that. Why didn't they understand that I needed help? Not nose-thumbing and insults?

I spent a great deal of time in those early years trying to appease them, trying to make myself into a homemaker they'd be proud of. It all came back down to that again. The home. Damn if I wasn't going to have a proper home like I always wanted. I let my eyes wander around their home, paying attention to how it was all set up, while they went through the same political and religious conversation they'd had for the last ten visits or so.

What I did come to understand, however, was why they were so miserable. There was no way for them to combat it other than to focus it on me, the last one to enter the

family. By contrast, my husband and I were in our imperfect home, happy together and doing what we loved. We were satisfied to work hard all week and then find ourselves at that same table where we leapt into the future together, with our CDs blaring, a couple bottles of wine, or a jug of rum on a Friday night. We loved talking about all of the successes and issues we had during the week, and just being in it.

Amazing really, how we could spend twenty-four/seven together and still just want to be with each other on those Friday nights. I loved our home, our little rented townhouse with our tiny yard, and strove to make it pretty and nice. I really did. I wallpapered and set up pictures in the wall unit. I kept it clean and tidy with a fridge stocked with plenty of fresh food. I remember two of my sisters coming in one day and looking around and saying, "Does anyone actually live here?"

The truth was, the picture frames in the wall unit still had the paper photos inside that frames come with.

BUILDING TRADITIONS

THE FIRST FEW YEARS OF MY MARRIAGE WERE EXCIT-
ing to say the least but seriously busy. We opened our
own distributorship; he worked seven days a week and
I worked six. I had the one day to take care of the house,
keep it and our life running. We spent time with his family,
but there was none left for mine. Yet, I was willing to sac-
rifice. I had what I always wanted: value. Value in myself
and in what I was capable of doing. I really was very good
at my job, great in sales, and I had the fortitude it took
to do it well. I was intelligent and could finally be in a
position to use it and be appreciated. But I was also very
dedicated to making the relationship work, so I spent most
of the time letting him make decisions about what we did
with our little free time.

Most importantly, I was happy. I loved him more and more as time went by. He was, for what seemed a long time, exciting, vibrant, and so charismatic that things were somehow not the same without him there. Everyone thought he was the life of the party. He was, if not to an extreme extent. But we were young, in our twenties, when you could still be out late, and still party, and still work.

He grew to love me more and more as well (that I know), but it took him a while to get over the one he didn't end up with. I believe men (in some ways, still as boys) never forget and sometimes never get over their first love. It was not long, however, before he was truly "in" it with me, with us together. There is no doubt and never will be, how much he loved me. We entered into this very unique way of always being beside each other. We did work together all day, but we never tired of it and we always had our spare time together as well. We tried skiing, really learned boating, and eventually became the best team on the water working our way up to a sixty-footer, took little trips on the weekends we actually took time off for, things like that. Of course, he was still trying to prove his worth to his parents, so most of the time we had to do things with them on our time off. They liked to party and talk politics, and the times we spent at their house was everyone at the table smoking, drinking, and still having those exact same conversations around all of the same things they didn't like. Exhausting, really.

It wasn't until I became pregnant with our first child, about two or so years into our business, that I slowly managed to change that. Weekends needed to be about rest as I was still working full time, right up to the end. These were very exciting times at our company. We were growing rapidly and doing well. I managed to secure an important contract with Nortel out west in the few weeks I was first at home with the new baby. I was on the phone in the spare bedroom of our townhouse while she slept beside me. Quite a feeling for me; I had worked on this project for many, many, months prior to her birth and I was not going to let it go. I'm sure that had something to do with it being awarded to me by the buyer as there was no doubt how dedicated I was at that point.

After I had my daughter, I worked from home two to three days a week and at the office the rest of the time. It was a precious time for my husband and me. We took parenting seriously. Neither of us had any experience with kids, but we stood together, learned, and did the best we could. It was all still magical to me, even more so at that point.

His old flame called one day. She had a habit of popping back into his life and he had a habit of taking the call and chatting. Shortly after my daughter was born, she called and I heard my husband speak with such pride.

"I'm a dad to a baby girl!" he said. "She's wonderful—want me to send a picture of her?"

"Wow. You really are taking this domestic thing far," was about all she said in reply. She passed on the picture.

Thankfully, she stopped calling.

Those were tough, hectic, busy, crazy years running the business and having kids. It was the most adventurous, exciting, and wonderful time. I was happy and in love and beginning to have a beautiful family. My son came along very shortly after my daughter. I got pregnant again the first night my eight-month-old slept overnight elsewhere. Two kids. Two cars. Two homes. The years rolled by expanding the business and we began to build an exciting life together. Soon, we were a major distributor with clients, offices, and warehouses across North America and into Mexico City. I was home for good after our second child came along. My husband was working for both of us primarily at first, and we were both excited to be, finally, not *always* together.

For me, much of the excitement of those years was gaining another place, as we bought a waterfront cottage on the Great Lakes. We were pleasure craft boaters before kids, so we decided to finally have a base up there to boat from. My son learned to walk there, and it soon became my favorite place in the world—from Thanksgiving where we decorated to the hilt and hosted both families as best we could, to snowmobiling in the winter to boating in the summer, and sharing it with as many friends as we could fit.

The Cottage itself really needed renovating, but the most we did at first was just replace some of the furniture and give it a face lift. We landscaped the yard; it was in serious blah-ness so we added hedges, grass, and decking with a big fire pit and a huge dock all built up beautifully. It had a grand beach that you could see from way out on the water. The front was paved for a driveway. We put down grass and shrubs and hung pretty country flags over the garage doors. It was a wonderful place—a haven—a sanctuary from city life and the hectic work world.

It meant everything to me having my traditions there; if there was one thing my mother did for us it was that. Thanksgiving with her was a nice, big food affair. They used to give me my own table where I would sit and eat longer than anyone else could, no small feat for someone so skinny as I was.

I wasn't skinny because I didn't eat. I was hungry, it was my norm. There just usually wasn't enough for me to eat, I always had a huge appetite. When I was eleven, I remember being taken to a doctor because I was so skinny. It was pretty much the only time as we were never taken to doctors or dentists growing up, so it made me feel important to have this attention. Unbelievably, the doctor gave me pills I had to take every day to make me hungry, to eat more. If they had just asked me, I would have told them I WAS hungry. But growing up my siblings and I were not

allowed to have more than what was handed to us. We could not just go to the fridge or cupboard and eat. Not to mention sometimes dinner was a pot of boiled beans. Pinto beans. White, with not much flavor going on, trust me. I despised them and still do to this day. Anyway, the doctor made it so that I was allowed to make a sandwich after I got home from school, before dinner. What a treat. And literally we are just talking peanut butter or baloney on white bread, not something of real big or sufficient substance, but it was heaven to me, as brief as it was.

When we moved back to Canada shortly after that, to the small cozy town, we spent the holidays with so many cousins, aunts, uncles, and grandparents and it became the warm part of my youth. It was those large holiday gatherings that led me into my forays with the Cottage: having many friends and family with us, decorating, and making the house very special. Even in the summer, beaching it with BBQs, boat rides, and campfires with plenty of Grand Marnier and gossip. It was a life I worked very hard for, getting it and during it. I exhausted myself taking care of it all, including what it took to entertain with young kids, but I wasn't "working."

It also provided my husband with company to drink with, which he also did a lot of. My husband had not only been working hard at the office, he had also been working hard on his alcohol and substance abuse.

Burgeoning into his own traditions.

Somewhere around the time my son was four and my daughter five, he began to burn out from working, husbanding, and parenting. He began to stay home too much, which only fanned the flames of his boredom. He didn't want the kids around all of the time and wanted me to "entertain" him. Translation: drinking with him, no matter where, home or on the boat (by now we had a lovely thirty-two-foot cruiser), but mostly at the Cottage. I was not a "partier" and wanted to do other things. But it was not to be. What I desired was not to be and discord soon arrived in our marriage.

When my husband was a teenager and young adult, before he was in my life, he had gotten into drugs. I still can't say the word to this day, so I will write it here once and then just say "the drugs" for the rest of this story, but he had been heavily into cocaine. Around the time the kids were four and five, and he was getting bored with domesticity, he went out to meet a few locals from our lake community where our Cottage was. Feeling his midlife crisis, his age creeping up (he was almost forty), he found himself on an island surrounded by a bunch of good ole boys doing the drug. My husband was all about proving himself, and at that moment he set out to prove that he could do it (party) better than anyone. And he started up again.

My husband was a very self-centered, egotistical, selfish

son of a bitch. He always was, but it didn't rear its ugly head too much in the beginning. He had been working on that as well. It did not occur to him that I was struggling at the Cottage for a couple of days with our young kids because on that particular weekend I had ended up with a very devastating, nasty flu bug, while he was busy "proving himself."

*

The true moments of that weekend will forever be etched in my mind. I was in bed for twenty-four hours and I had to ask my five-year-old daughter to leave the blinds down, the door locked, and watch her brother while they watched cartoons. Memories of them pouring cereal and spilling the milk onto the floor by the fridge and trying to clean it up. So, so cute they were. Of me waking up every couple of hours to find a fresh glass of water by my bed and my five-year-old daughter sitting on the bed just watching over me. No, I will never ever forget that, and of finally getting up with just enough strength to make some soup and eat it with them at the table and watch my precious kids. This was surely an omen of things to come with the three of us working things out together. What is notable is that I somehow knew that day that I no longer expected my husband to come home and take care of us. How did I know that? So, just tough it out? Little did I know, it was the precursor to what was going to become the norm. It was the end of the nineties and the loss of the magic.

It was a slow buildup and we were yet to also experience many good things in our lives. But that was the moment: the beginning of the end. Things were going to change, big and hard, but I had my life, my house, my kids, and I was going to learn to fight with all of my worth to protect us all and get through it.

It seems grand, that notion, but I didn't know for quite some time what was happening. The next few years were a constant rollercoaster, emotionally, physically, and mentally. But that was my husband. When he walked into a room, he sucked out all of the oxygen. He, quite literally, made it all about him. It wasn't until much later that I realized how much I needed to breathe.

CHAPTER EIGHT

THE HOLIDAYS

AROUND THE TIME MY KIDS WERE SIX AND SEVEN, WE began renting a condo in Puerto Vallarta, Mexico. It was a great vacation spot long before the cruise ships started docking. The Christmases at home were becoming just too much. His parents ruled Christmas, beginning with an all-night party on Christmas Eve. Presents literally flowed halfway out onto the floor space of the large living room. A banquet feast of marvelous food accompanied drinking. Opening gifts would take until the next day to finish. We were joined by many of my husband's family and their friends. It was lavish enough to keep his mom busy preparing for the whole month of December. Decorated to the hilt, including all of us in our best clothes, it was truly wonderful before the kids came along. Who DIDN'T want to do that all night, sleep late the next day, and gorge on yummy leftovers?

The problem was that by the time the kids were six and seven, they were so inundated with gifts by his parents that it became a tradition of: open—exclaim wow—toss over the shoulder—grab the next one...repeat.

The following morning, Christmas Day, was for me to do the "Santa" thing, and there would be my few precious things under the tree. I would stay up late into the night after the party and set their gifts out for them as Santa would have, as in all the Christmas stories I read with my kids. It was a tradition that was very important to me to begin with them. I even imagined how they would grow up and do the same with their own kids.

"Don't you think it's just too much for them doing that, too?" his parents would ask.

Seriously.

I could not say much; that would have started an all-out war, which my husband would not have supported me on. I smiled through tears but didn't give up. I lived for my kids during their growing up years. I always said the same thing to people when they exclaimed how much quality time I was giving them, staying home from a career.

"I only have them twenty years. After that, I'll be done talking at them," I would say. "I'm going to live to be a

hundred, so what's twenty years for that?" I knew exactly what the other side looked like and I wasn't going there, not a chance.

With the super late nights, and then moving everyone on to our Cottage for Christmas dinner, plus the fact it was normally flu season...the kids got sick every year by Boxing Day and down we all went.

Our answer to all of that was to say screw it, to take them south for a few weeks and only give them gifts that could be packed in our suitcases. While there, in Puerto Vallarta, which we called PV, we took them to a church with a real live manger, live animals and all, and we brought them into the local community to share their good fortune with the less fortunate. It really was special. My husband and I cherished those days and continued to do it for a number of years.

We met a man in PV that quickly became one of my husband's best compadres. He had a lovely wife who spoke no English, but she and I got along wonderfully; they had four kids right around my kids' ages. By the second Christmas there, we were renting a condo on a yearly basis and spending most of the school holidays there. We all, as a family, became very close to them. It was one of the happiest times we had together as a family. We shared much of our lives together with the other beautiful family.

The problem was, my husband needed company to drink with, and to show what great things he had from the successes. Truthfully, we both enjoyed sharing what our wealth brought us. With the Mexican family that lived in PV, our husbands became extremely close. Mine garnered all of his attention when we were there and we relied on him to take us around safely wherever we needed to go. He also provided my husband with a drinking buddy and, eventually, all of the drugs my husband could do, and wanted. During the second year, it was brought to the condo as soon as we arrived, and I'd then usually spend the week by myself with the kids on the beach while he stayed in the condo with his dope.

The first time we arrived in PV, neither of us had been there before and did not exactly know our way around. We rented a villa outside of the hotel zone but within walking distance to a smaller part of the community, which we grew to love over the years. That first night, we went into town in the afternoon and stayed there to eat and drink. When it was time to head back, it had gotten dark and the streets were pretty deserted. The kids were beat from the travel—we had only just arrived that day from a very early flight. As usual, my husband had a lot to drink (probably tequila which worked like a drug on him). He could drink, I tell you he could *drink*. It was a pound down the first one, making the waiter wait while he did, and then say "get me another one" kind of drinking.

That night, we were making our way back towards the villa, and he thought we were going in the opposite direction. He insisted it was back the other way, but it wasn't. I knew that for sure because a: I wasn't drunk, and b: I have an innate sense of direction. I always know which way I am facing and which way I came from. Once I've been somewhere, I always know how to get there, or back. So, there we were, with two young kids in a dark neighborhood we didn't know well, and he stomps off. Literally, he storms off, at a pretty fast clip, in the opposite direction of the villa, I was sure. Even if I wanted to, I would have not been able, with the kids, to keep up with him. I certainly could not just stand on the corner; I had to move. I had to keep moving and try to figure out exactly where the villa was. I was trying to prevent the children from knowing I was afraid and keep them calm without attracting attention. I was scared shitless all the while. It was probably half a mile on, but it was the longest mile for me.

Who does that? Who leaves a woman and two young children out there like that? It was not a crowded, well-lit tourist area. This was a neighborhood of sorts with condos and businesses, closed by then. No taxis on every corner. The few that drove into this zone were already carrying passengers. I passed a few men and a couple of women who stared at me. Furious was something I was going to have to get used to. Unfortunately.

We made it. My husband showed up not long after, no

apology, or anything about it, just glad to be back, and made his way to carry on with life. Nothing but snoring all night and reeking with the stink of greasy booze to the brink. Something else I would have to get used to. Unfortunately.

His excesses on those trips eventually got to a point that we had to force him to get to the airport on time because he was unable to leave his sanctuary, his haven. He even tried looking into schools for the kids there, but that was a definite no from me. This was in the days before I knew about the substance abuse. All I really knew was that I was the only one looking after the kids and having fun with them; he was just not around us much.

The few years during and after having the villa was no less dramatic. All of our vacation time throughout the year was spent in PV, with my husband's compadre and family. There was no choice. We had to do a connection through Mexico City sometimes, and there would be a few hours wait between flights there. On one particular trip back, he was not at all happy to return because the holiday break was over, and the kids had to get back to school. He put a major pout on all the way from the airport and through the first leg, drinking heavily all the while. When we got to Mexico City, our airline did not have an assigned gate for us. They would not have that information for a while, but the agent in the hallway my husband flagged down

promised to let us know as soon as they did. This was not good enough for him. It behooves me to reiterate here that, at this point, I alone was responsible for the kids. It was me who would watch them, take care of them, and pack for them. I bathed them, made sure they ate, didn't get lost, got to school, and on and on.

I was standing there, holding onto both kids, in the middle of a busy, large airport in Mexico City. My husband stomped off. With our tickets. Now, in those days you had the paper things, sleeves that are torn off out of a booklet at each leg. We had those, or we may have gotten the next boarding passes at the departure out of PV, but you get the idea. Whatever form it was, they were with him.

He yelled at the airline rep, but good. This was before they were higher ranking than deputy sheriffs or Special Ops. I stood and watched the back of him march away and get swallowed up by the crowd down the long, curving hall-way. I looked down at my kids, one on each hand. Again, all I could think was: who does this? I remind you, this IS Mexico City. Do you know Mexico City? Yes, think of everything you know of it including a very large city pop-ulation with crime to match.

Quite briskly, I walked down the hallway, having no idea where our gate would be, but I would figure it out once it was posted. There wasn't likely to be more than one

Air Canada flight out at our time. I needed to "move with purpose" as I later taught my children for safety reasons. I did not want to look lost, in distress, upset, or even exasperated. Being vulnerable was NOT on my radar. Brewing anger *was*.

Once again on my own in an unfamiliar place, I took the kids over to a near-empty seating section between departing gates and pretended like nothing was wrong. I made up a game for us to play to pass the time. I had one eye on the hallway. Sometime later, he found us and simply sat down. I didn't say anything; I could not let the kids see my anger, which would be impossible to miss if I spoke to him. He may have mumbled an apology; I honestly don't remember, but I knew for certain he had stopped at the bar and was feeling better. This was not going to be the worst I would endure, but it surely foretold what kind of life I was in for.

Shortly after that, I spent many a day staring out of the car window, wondering what life was really like out there in *that* world I could not seem to grasp. Many, many days I did that, particularly while he was driving, and I did not have to focus on the road. Where this road was taking me was much more time, patience, begging, pleading, and crying that I didn't even know I had in me. For the time being, all I needed to do was survive and keep my children from knowing the truth and true pain of it. That was my

job and I took it incredibly seriously. At that moment, it simply was not an option to run away. THAT was my value now. It kept me centered, busy, productive, and focused to keep the kids on a safe, normal, and fun course. I was both parents, a course that left me beyond exhausted. I have never known exhaustion like I did in those days. But they were my kids and they were not going to hurt, over my dead body. Those two precious beings were my everything, and I loved them more than life itself. Beautiful, innocent kids.

RED HOUSE, WHITE HOUSE, BLUE

IT WAS TIME FOR THIS HOUSE TO GO. IT WASN'T working. It didn't work, it was bringing in some dark and turbulent times. I needed a new one.

My husband and I bought the Red House, our first home together, when our daughter was three months old. Our company had begun to show its great success and it was time to make room for a home big enough to fit our new family. We knew we would have another child, but it was also for our new world: Big Business. We could easily afford it, but we were still careful, never extending ourselves beyond what we could remake in revenue. It was a brand-new development. We chose our home from the models and, during the pregnancy, made all of the choices for the interior. It was a very fun time for me, as you could

imagine, but did not come without some exhaustion as I was also still working full time and getting further along. This was why I went mostly with what my husband wanted in choices. After all, in my eyes he had grown up in a real home and his parents' house was always so well put together. Not to mention I actually agreed with him. That was one thing that united us well; he did make decisions in life for us, but I agreed with the majority.

The house was going to be ready to move into in June, after my daughter was born in March. It was such a feeling of accomplishment for me; it made me leap for joy in my heart. Here it was! I was going to own my own home, my name was going to be on the deed alongside his, and it came from the success I had through hard work and determination. A baby, a man I loved, and a brand-new house that I could have the way I wanted. It was a beautiful two-story, red brick home with four bedrooms—a great kitchen for me, especially important—brand new appliances and a dishwasher to boot.

There was a back deck that led down into a tidy yard where we had put in a custom cedar hot tub, looking out on a green pathway. We designed and finished the basement with a big screen and surround sound, carpet, big comfy leather chairs and, of course, a bar. There was a walk-out onto the back deck. When you sat in our hot tub in the winter, you could see inside to the fireplace that was always on.

My son came along in our first year at the Red House. We had Easter dinners for all kinds of family, Christmas parties for adults, and birthday parties for kids. Our kids had their early years of school there and made friends in the area. It is true what they say about giving your kids the toys you wish you had; I loved moving into the great zone of Hot Wheels and Barbies. But, for me, it was also special because of the kids' moments I could create. One of my favorites was beginning the tradition of Halloween with them, having pizza first and walking along our friendly street.

One day, I knew we had to leave. I had to search for a new home, find a new neighborhood, and start over. The Red House wasn't working. I knew this the day I got off the plane from Mexico City. Enough was enough and I needed to save my family. I knew my husband was an alcoholic at this point, I just didn't know about the drugs. I had no experience with it in my life and did not recognize it. I just knew that whatever IT was, it was wrong.

It took a few more years before we moved to a new house. During that time, I got more desperate. My husband was not leaving the house and I was suffocating from being in it all of the time with him. Mostly because he simply would not do anything but lay about during the week and then get up and party on the weekends. Sometimes, thankfully, away from us. He harassed me with questions about where

I was and what I was doing when I was out of the house. Trust me, I was mostly wandering around a mall just to get away. That was part of what the drugs did to him—the paranoia. It took those extra years to get him out of that house, that comfort zone he buried himself in, while I learned to hate the Red House so much.

I still remember the exact day we made the offer on the White House. I found one in the neighborhood where we moved our kids to a new, good school. It was as far as I could get from the current house, yet remain in the same city of our business. It was in the best neighborhood, very well-to-do, with big exciting homes, larger properties, great mature trees, and a different sense of well-being. You could walk to the cute little shop district with family-owned businesses and to the lake. Our old neighborhood was a simple cookie-cutter development you would call a "bedroom community." I found this new area quite enchanting while I was driving around before picking up the kids from school. That was something I did to get out of the house earlier. We looked at houses for quite a while when this one was brought to our attention. You might call it my dream home.

It was marvelous, just so marvelous, really. It was on a cul-de-sac with a lovely, garden-filled yard both front and back. It was a very large home with perfect bedrooms for us and each child. The kitchen was huge, and of-the-times

appointed. The family room was a high-ceilinged room with a grand fireplace. It had a porch (my secret fantasy) perfect for a comfy rocking patio chair, which I bought on the next Mother's Day for myself.

I had to take care of those needs on my own for a number of years. I sometimes bought jewelry, flowers, and other little gifts for myself. When my kids were young, I was usually at the park with all of the other fathers on Mother's Day. I would imagine that their wives were pampering themselves with a foamy bath of "gift stuff" after breakfast served in bed. It seemed I was still dreaming of what life was like for the other girls in "this" class.

There was one time he had to show up and I will never forget how it happened, or how I accepted it. I pretended it was meant in only a good and special way in front of the family, even though I knew the truth. It was staring at me in the face. He was sweating and anxious to be done with the task. Also, anxious for me to think of him as a hero. His perch, the pedestal I had him on, was tilting sideways and he was falling off. It was one of the last days in the Red House and thank heavens we were moving.

It was my birthday. I was at home sitting alone, nothing unusual really. I remember the kids were still at school; it was early afternoon. My husband was coming back from being gone for quite a few days up at our Cottage, again

nothing unusual. He told me to be dressed nice, and then had me sitting there for a couple of hours waiting for him to show up. In the future, that scene would play out many times. It was a two-hour drive home from there, and it would always be his last-minute decision to see if he actually wanted to or could make that drive. He would spend hours telling me he was on the way, but you just never knew if he was until he finally showed up. If he did show.

He finally blew in, that was his way, to just barrel in the door very loudly and take over. It was his way. A standard of blowing off that he'd been a dick, not giving me a chance to say anything first or, God forbid, complain. He rushed in with a bottle of champagne in one hand and a gift in the other. He immediately opened the champagne and poured a generous helping for himself, drank it all down, then poured himself another. It was my birthday, so I suppose that was why he managed to pour one for me as well on the first round. It was normal for him to do it on the second.

In the box was a brand-new Rolex. He was grinning and excited to give it to me while he was wiping the sweat off his face. As soon as I opened it and showed my thanks, he was done with the moment. We were not going to go out for lunch as he had said. He went upstairs and I picked up the kids. I found out, not too long after, that a friend of his had done the shopping for him. This man had actually chosen it and brought it up to our Cottage for my husband

to come home with. I also understood this gift was a hush up. This was his way of saying it was all okay, not to "get on" him, look how much he loves me, and what he can do for me. That is the only way I can think of to describe it. He bought me at that moment, my devotion and dedication to him and our marriage. He also told me to show it off to family members and friends, he wanted them to know what a wonderful man he was to me.

I kept the watch. I love it. I honestly never felt bad about that. It became my signature and I was never without it, usually one of a few pieces of jewelry I would wear at a time. I deserved it. Every single thing about it. It was very me, and it made me proud of what we had accomplished together in the business we created. At the same time, I was beginning to learn a few new things about myself and what I was going to have to do to survive for the time being. Moving was a priority. And I greatly desired to make the White House a very special one, to start a new chapter, to make things right again. I didn't want to just survive, I wanted to live.

But that wasn't the hardest part, getting through those tough times, those ridiculous moments of pain. No, the hardest part, the thing that was the worst to go through, was that we still very much loved each other. Neither of us wanted to give up. Neither of us ever thought it couldn't be fixed. The toughest lesson of them all, was perhaps that

it wasn't going to be able to go back to the way it was. But we were both willing to try.

In the bathroom off of our bedroom in the new home, the White House, both of us on our knees, facing each other, both of us crying, we held onto each other for a very long moment.

"I just want to be a good father, and I want to be your husband," he said, breaking down to me. "I am just so sorry. I promise."

"You have to be. Or else," I said. "This is just too hard."

I know we held each other for a long time before we could let go. It was mostly in silence but a rare time that he could speak about what was happening. Those were the hardest moments—to wish so hard for it to be true, give it time, hope and pray for it all to matter still to him—for us to matter to him, yet not knowing at all what was going to happen. He made promises before, but this time he had to mean it. I had found out what "it" was. "It" was the "drug." I had proof and there was no denying it now.

And so began the cycle. For three months, he was the best father he was capable of being and a great husband, as much as he was capable. He stayed away from the people and places that brought him down into the other world.

The kids and I were so happy. It was always wonderful, fun times as a family like that. The way it was supposed to be. In the grand White House in the grand lush neighborhood.

But that is what led him to do it again. The minute it was all back to normal and he had made everyone happy again, off he would go.

CELEBRATIONS

THIS IS A VERY HARD CHAPTER TO WRITE, AND FOR you to read, I'm sure. It's about birthdays and other assorted celebrations, particularly *my* birthdays. The kids had great ones because I was always there for them, as opposed to their dad's part-time attention, and I endeavored to make them special. I lived for that shit, as they say. It was a wonderful experience for me as a mom, and I took it to heart. I did not have birthday parties as a child, or any such fanfare that I can remember, to be honest. But that wasn't something I had bad feelings about. It was simply one of those things that, as a parent, became a joyous thing to do. Like buying the toys for them that you never got to have! Guilty.

My son's tenth birthday stands out as one of those special moments. We were at our Cottage on the lake. As I said, it had a rather grand beach, facing east as the sun came

up on a lovely bay off from the main channel. The water was shallow, soft, and warm. It was my private pleasure, my favorite place.

I spent three days before his birthday creating it. It was in the days that *Pirates of the Caribbean* and Captain Jack Sparrow were a pretty big deal, especially to my kids at the ages of ten and eleven. I took a large sheet of paper (the kind on easels that you draw on for group presentations) and soaked it with tea to "tarnish" it, to make it look ancient. Then, I went down to our beach, walked out certain steps, and made note of a few details. I had bought a small, old-fashioned chest and at that time you could buy an actual key that looked like the one from the movie, the usual movie paraphernalia. I put the key in the chest and buried it about a foot down in the sand.

When the map was dry, I burnt the edges in a rough way and then I drew a treasure map on it, complete with instructions and pictures. It looked very authentic, the whole shebang, the scrolled words rhyming exactly the way Jack Sparrow spoke. Then, I rolled it up and tucked it into a small, velvet drawstring sack. On the day of his birthday, it showed up on the table with all of the other gifts, with a card that read: Happy Birthday from Jack Sparrow. Even though we were at the lake without many others around, we managed to have a few extra kids there to join in the fun. They were just so excited, and it was so much fun. To

watch them look for the signs, figure out the riddle, count out the steps, and then dig and find it, not without a bit of pride I loved it so much.

It broke down to this: I took care of absolutely everything—the gifts, the food, the fun, the kids, and the barbecuing. My husband sat up top where the decking was, away from the beach, glaring. He was unhappy having to do this instead of what *he* wanted to do, and there was no question he was coming off of a major drug week. He took care of inviting adults to party with. They showed up, and a few drinks in, he was getting back to himself. Kid stuff over, down to the beach he came. The Life Of The Party. It didn't matter. I did what I wanted. I really had so much fun leaning into the creativity. Watching the happiness in my son was worth it all. Every single heartache.

Despite that, it was actually one of the "good" celebrations, and at that time, the kids were too young to really know the issues. I was exhausting myself being both parents and not letting them see what was really going on. There would be time to sleep later. This was my priority, making sure they had a "normal" life growing up. It was so important to me and it was in my power to do so, I believed. I was in control of their raising, and it was going to be alright.

My birthdays bore the brunt of it because I couldn't exactly do those for myself. When my kids got a bit older, they

spent some time making it special for me, which I will forever be grateful for. One year, while my husband was "up north," his home away from home with freedom to do as he pleased, he couldn't get himself home for my birthday. He really wasn't going into work at all at this stage; he was managing from home on his Blackberry. So, for my birthday he told me to drive up to him without the kids and he'd spend some time with me. Sure, out we went overnight on our boat doing what *he* wanted to do, and drank. The next day was my birthday and we were planning on being back at home with the kids. We arrived back at the marina in the morning, reluctantly on his part, and he had been drinking already. We docked and began to close it up. There were others around us on their boats that seemed to know him quite well, but I didn't really know them. They were excited he was there and looking for him to join them. He sent me home ahead of him, the two-hour drive back. There were dinner reservations at one of his favorite restaurants and he had arranged a limo for us all. When I got home, the kids were all dressed and excited, and they showed me proudly how they had made me a cake with my sister, who had stayed there to look after them.

I got ready, all dolled up. The kids looked nice and stood out on the driveway waiting for their dad so we could go. It started getting late, the limo had arrived, and the driver was impatient because he had another service to do, but

my husband still hadn't shown up. I didn't go outside to wait with them. I sat in a chair right inside the front door and did not move, not even when he blew in the door in a heated frenzy. I guess he had passed the kids waiting.

"What's your fucking hurry?" was all he said to me. Just like that.

Without even looking at me, he went upstairs saying he needed a shower. How can I remember all these details? Because I will never forget that hurt and that anger and the fact that I wanted to kill him for what he was doing. I thought I could get through it, but what I could not handle was what it was doing to the kids. My children. I did not say a word.

"Take a shower," I soon came to learn, meant, "Do a line." He came back down shortly after and said let's go as he walked right past me and out the door. A miserable ride and silent dinner later, we came back to the house and went to the kitchen for my cake the kids had made. At this point, I was still determined to not make it a total loss for them. I was just glad to be home. My husband just sat at the table all stupidly morose, and when the kids brought the cake to the table lit with candles and started to sing, he said, "We have to have cake, too?" Just like that. With contempt.

I turned, looked at him and spoke only two words, with complete vehemence but deadly quiet: "Get out."

CHAPTER ELEVEN

AND DOWN WE GO

MY HUSBAND STAYED AWAY FOR ABOUT A WEEK OR SO, but he eventually came back. He had his tail between his legs. He was gone just long enough to get everything out of his system and realize that he needed to do better. The business was at stake, and so was our home life. He wanted both. But for him, it was even more about what other people thought of him. It was about having the house in order, with a lovely wife, two amazing kids, and a pretty grand lifestyle. It was important to "show" that to others. I always knew that about my husband. He may have been whitewashing everyone with his charm, charisma, and grand boisterousness, giving things away to them, but I always knew why. It was all for their faith and loyalty, which was going to come in handy in many ways someday. Along the way, he was becoming a very accomplished liar and egomaniac. But that is not unique to him; alcoholics are famous for it, drug addicts even more so.

Strange how I can see something now, so clearly; I kept trying to fix the White House without really knowing what needed to be done. There were rooms and flooring and bathrooms that I kept focusing on changing, things I didn't particularly like, when in actuality I really loved my house. I would catch myself staring into a room from another and marveling how much I loved and was grateful for it. It was very symbolic for me, the constant wanting to "fix" something, and its true meaning does not escape me now.

At this point, my husband would be away at the Cottage all week by himself talking about all of the "work" he was doing there, like organizing and cleaning things out. Notably, he had changed the locks and never gave me a key. He had to be sure I didn't just show up and be able to walk in. After he was there for a few days or so, the weekend would come, and he would keep me on the phone on Friday making sure I did not have plans with anyone, that I was just staying home. More importantly, that I was not driving up. He would also make sure I understood he just could not finish the work he had started in time to be home by that night. The same work, that somehow, miraculously, never showed any evidence of being done. Then, early on Saturday, he would tell me to make a reservation at whatever place I wanted, the nicer the better, and to get dressed up real nice and he'd be home to take me out.

I would.

I would have the kids settled elsewhere with friends. The house was quiet. Everything was in its place, all tidy and clean and ready for special adult time. He would message during the day how his progress was going and to be sure I was still waiting. At four o'clock, I would take my time getting ready. At about six o'clock, I would open a bottle of wine and sit at the kitchen counter, all dressed, music on, and wait. Around eight o'clock, I would go upstairs, change my clothes, and put the wine away. Forty or so years later and I was still staring at the door, hoping it would open, that I would hear the sound of a car in time. There was no car, just another weekend alone.

It was always too late to make plans with anyone else, but he didn't really want me telling people about this. It's something scam artists are famous for when they have you; they're afraid you'll be told or shown how ridiculous it is. There were times when he often would say in a message: "Oh, look it's after three and I never drive home if it's after three. It will be tomorrow now." Those Saturday nights went something like that; he would excuse himself later. What he didn't even realize is that he would spend two hours saying he was heading out.

I did come to realize he was dangling me, making sure I wasn't going anywhere else, and especially out with anyone else. Paranoia was a big thing while he was on the drugs. But I kept doing it for a while (he was, after all, the best

salesman I ever knew). Dress and sit, wait and undress, and then cancel the dinner reservation. The kids never saw my disappointment, my shame at myself, my sadness, my embarrassment, my feeling of stupidity, my despair, my loneliness and isolation, and lack of control over what was happening. Heads up: I've got this.

You know it's bad when you are still making excuses for someone like that. My husband, he had it all. The freedom to do this and to know his wife was dutifully at home taking care of his whole life. How wonderful for him. How truly sad for me. I never went out of the home looking for love, as I watched many other women do when their husbands weren't around much. I didn't need someone to make me feel like a woman; I knew who I was. I always did. I didn't need someone to buy me special things, I had already been doing that for myself for a while. I wasn't sure exactly what I needed, or how it was going to happen, but I did know I was not the same person I was when I grabbed onto the tail of that white shirt and "went for a ride" twenty years earlier. I hadn't been myself for a long time and I was tired of hiding the truth from everyone about what was really going on. What I needed was someone to listen.

The moment finally came, when I knew I was no longer in love with him, but I also knew he was no longer the man I married, believed in, and trusted. It was during my daughter's eighth-grade graduation. She was honored

with three awards that day, which we found out during the ceremony; they were for citizenship and two subjects. She deserved it, truly.

It had always been my job to make these moments as special as they could be, things I would never let the kids down on. These were things I never had, and I wasn't jealous, not at all. I just wanted them to fully experience them, those moments you don't get back. Especially if it's being rewarded for working as hard as my daughter had.

She and I spent the day as most of the other moms and daughters had. There was a lot of pomp and circumstance in the neighborhood of the White House, faded beauties reliving youthfulness and pushing their daughters forward with as much glitter and attention as could be mustered. But for me it was about having this connection with my daughter emotionally, of seeing her blossom. It's kind of like the enchantment in the smell of pharmacies that I remember walking into as a kid: the smell of lipstick and bubble gum, a combination of the child she still was and the woman she was becoming. She and I had bought her special dress downtown together. I had a hair appointment arranged for her that day and a very sweet special young teacher at her school was offering to do the makeup on some of the girls.

My husband was not home. He had been "away" for a

while. It was getting down to the wire and this was one of those occasions he HAD to make it back for. Typically, he would take that out on us, at the best of times, but I vowed not to let that happen on this special day. The flowers and balloons I had delivered to the house arrived late morning. My daughter would be home soon. Lunch, then makeup, then dress, then head to her friend's house for photos with a few others. My husband blew in, saw the apparent festivities and walked by without acknowledging because, honestly, how could he? It was easier not to draw attention to the lack of himself. He flopped onto the couch in the family room, laid down, and turned on the TV.

My daughter came home and I went to make her some lunch. He raised his head up long enough (you could see the couch he was on from the kitchen) to speak to us.

"What about me?! Hey, don't I get any lunch?" he said, quite indignantly, with a sour look.

"Of course," was my only reply. This was not going to be a problem, not today.

Shortly after, my daughter was dressed and ready to go to her friend's house; they would take her to the school and we would go later. My husband was still laying on the couch, like a disgusting slob was all I could think, and he repulsed me. I could barely look at him. He was picking

his nose, blurry-eyed and rude, like a neon sign above him saying so. I stood in front of that room in the hallway, announced my beautiful girl as she came down the stairs and watched her stand in front of the living room while he raised his head off the couch. He told her how wonderful she looked, and then asked what was the latest time we had to be there. He did not get up. Sadly, that is not the end of the story.

We got to the school auditorium. I managed a seat right on the aisle quite a few rows back. The kids all looked so excited and nervous and wonderful in their formal clothes. This was such a proud and special moment for me as a mom. It gave me such real and genuine pleasure to see my daughter win those awards, the kind and humble person she was, being good to others for the sake of being good to others, not her resume. But I had to sit next to my husband, whom I had picked up off the couch a moment ago. I was lucky to get the good seat as he made sure we didn't leave the house until we absolutely had to. During the ceremony, he hung his head down, not listening to a thing that was being said. He asked me during or after, I can't remember which, what awards she had won. He was more about "could this please be over so we could go." We were slated to go to a local favorite spot for drinks and dinner after while she went to a little party with her friends.

I liked being involved with her friends. I took parenting

seriously, yes, but also truly enjoyed all the stories she would share with me around them. I didn't realize until much later how I was eating it all up with an appetite that was burning in me since I was a kid. I didn't have that, the longevity in one place, because of all the moving around we did and it was very special to me to get to know her friends in such a nice way. They were good kids. So far, anyway. They were still young and mostly innocent. I loved how they all liked my daughter, she treated everyone the same and with respect. I was also particularly proud of that. I had been raising my kids that way, to know compassion and also having dignity, all about what is right and what is good. That moment in the 7-Eleven comes to mind many times when I see my kids making the right choice to be a good person, to share with those who are without, and to care when someone is troubled even if it has nothing to do with them.

I was proud of my daughter on that graduation day; my heart swelled, for her and for me. I took a measure of credit for getting my daughter to that point despite much of the heartache the kids and I had gone through for many years prior.

We were all standing out on the lawn after the ceremony, the kids were doing the usual running around whooping, while parents were hugging and taking proud photos. You'd think someone split the atom or invented cold fusion or

something. I was standing in front of a group of my daughter's friends as more were piling in for the picture I was taking. I still look at that photo today with a big smile. So candid and so perfect. My husband was there on the lawn, somewhere, and he finally tells me we have to go. Enough. No more pics, let them be. A hug and kiss for my daughter as I say goodbye and take her certificate with me. I stare a few moments longer as she runs off, in awe of the moment.

Afterwards, my husband and I reached our final destination, a local family-run Thai place. I loved the food there. The very moment we sat down my husband snapped his fingers for the waiter. The waiter came and my husband asked him to go get a double bloody Caesar right away. When the waiter turned to me, my husband told him to just go and bring his drink back. Without a word, the waiter left, with a slight nod from me. I was sitting very still in my chair, not moving, staring at my husband. I was not saying a word. Just a few tables near me was a pretty young girl, who I thought might be in my son's class and she was smiling over at me. She was at a table with her parents. I did not engage with her, I turned away. I hid myself from being known with this individual, who was my husband and behaving so badly. To this day, I can still see her sweet smile and little wave and I feel so bad that I could not give back. I know it must have puzzled her, and it's dreadful to me to think I appeared like one of the "snob moms" of the neighborhood, which I never was.

The waiter came back, my husband grabbed the drink and told him to wait. He knocked it back drinking it all down at once, put the glass down on the table, told the waiter to bring another, and only then looked at me and asked what I would like.

I wanted to be done. I had to figure out how.

Part Three

A FEW MORE
HOUSES

THE DANCE

MY HUSBAND AND I SPENT THE NEXT FEW YEARS doing the dance, waltzing back and forth from a semblance of normalcy as a family when he was being good, and the disastrous scenes when he was bad. The cycle was on, but it was not as often as every three months as it was previously, and it was, for a time anyway, not as bad. But I have a feeling that I was in control of the outcome, I knew what would happen and the best way to deal with it. I was getting very good at damage control. I was continuing to build a life for the kids, encouraging activities and friends, only wanting them worrying about their teenage problems.

The Company we founded together was doing well. Very well. We had laid a rock-solid foundation and my husband was, quite literally, a genius in business. With no formal education, just an ambitious drive, he was a risk taker and one helluva smart cookie. My kind of man, yes, but very

me as well. Everything I learned in those early work days with him served me well and served us in our purpose building a successful wireless cable distribution. By the time we were at the middle of the first decade of the millennium, there were offices and warehouses across North America, from the Eastern Seaboard to an actual assembly plant near the West Coast, and a burgeoning satellite office in Mexico City. Our primary customer, Nortel, was keeping us very busy as we took more and more product and work out of their plants and into our own warehouses. Value-added services as well as earning QC status to ship direct to sites turned us into more than a stocking distributor and afforded an opportunity to look into other markets such as radio technology. As many know, Nortel disappeared. By the end of that decade, the Company went into other similar avenues, inside a newer, larger flagship facility down the road from where it all began.

It begs the question, during my husband's self-destruction and subsequent absences, who was minding the store? In the early stages of it, he was still leading, and it continued to do well. Maybe not growing but still operating at a profit. There were a few people in high positions at the Company, those we brought in early when we wanted to keep it very under wraps where the Company was developing, family members and close friends making things work. But, and this was increasingly apparent, four of them could not do what it was that my husband could do

himself, as he so aptly put it. There was never any question to him or me about that and we shared that particular feeling many a time.

That was the thing about my husband and I, we had a very special connection right from the beginning; we thought differently than most people. We got each other's jokes when no one else in the room did, and we would just laugh anyway. We had a wicked sense of humor and had a great many "private jokes" between us. We were never apart for all of the early years, and I think that once that began to be lost it wasn't going to come back. Yes, he loved me as I loved him, but sometimes there are just too many things beyond your control, beyond what you can "earthly" handle and it sweeps you away in the tide so strong you can't swim your way back. You can try, and keep trying, and really want to, but the opposing current is just too strong, and you have to let go and let it take you. I really believe that is what happened. At that point in the Company's story, he was fighting to get back to what was, most especially the hero he yearned to be and had been to many. Sadly, he began to use any measurable means to do that, even if it meant throwing me under the bus.

No real surprise to me, my husband managed over the years to "own" his top men, the ones leading the charge at the Company. I particularly loved the exception—one of the four was a lovely, consummately professional woman,

well respected for the intelligent straight-up woman she was. She was the greatest asset we had. You didn't fuck with that; you just hoped she stayed. The owning of the others, though, was what he learned from the very first boss we had when we first met, working together. Over the years, my husband paid mortgages, held secrets the wife shouldn't know, gifted fabulous trips, and on. It was easy for him to insist they not speak to me and made sure I did not have communication with them. I was the "excuse." For as much as he was not showing up in our home life, he certainly was not showing up for them, either. Not the day-to-day, he didn't need to be, but for someone's fiftieth, a retirement, or an actual "wedding" to which was booked, rooms and all. He was going to miss them. It was going to be my fault.

I found out by accident that I was blamed as the reason for him, and in some cases us, not showing. All the bullshit of "we were fighting" and how I was "planning on insulting them all at the party," or how much I talked of "hating them" kind of nonsense. Yes, I was very angry at the time that he could do that to me but really was not shocked, and it was not the worst he'd done by far. What really upset and angered me, probably disgusted me to be honest, was that they actually *believed* it.

They never questioned it, spoke to me, or gave it a thought that they had never witnessed this behavior in me. Yet,

they took it as truth from him. These were people I had known for probably twenty years, but everyone wants to take the easy way out. How easy was it to stay in his favor? He was the man who paid their salaries and bonuses, and for their vacations, cottages, and concerts with party buses. Yes, he did all of that for them. No one wanted to really hear. They also knew how difficult he was at times and I'm sure they wanted him to stay "my" problem, and they could always just go home. He was childishly difficult with everyone.

Shame on them. It seriously put me back to that Christmas play being Lucy at the age of nine and the teacher never asking me what happened, just walking away from me in disgust. Because that is exactly what they did, these friends and family of his. Because, clearly, they were now *just* his. I was cast out, given glares and the silent treatment at the odd time we were in the same place. I kept silent around it, put a brave face on. It was evident I was going to be alone in this. The full capacity was not even realized yet; that was to come—the day I had no choice but to fully walk away.

I went back on the floor with the Sears catalog, except this time it was a chair in the guest bedroom and a laptop. And it wasn't just furnishings this time, it was entire houses. Realtor worlds became my new fantasy and I lost myself for countless hours looking. I was on the hunt, a place to

rent maybe? A place I could escape to? A place of safety? A place to park myself and my kids away so he would understand the seriousness of his behavior?

Was I willing to admit to myself that he would care more about what everyone thought than he would that I was gone? Would I pull it off without him being vindictive and do what he could to cut me off money-wise, one of my realistic fears? All of these thoughts circled around in my head while I looked. There was no harm in looking, no harm in dreaming, in escaping the reality until I could be in control of it, just like that nine-year-old had decided.

It turns out, later when a move came to maturity, that I was right. He stood in front of me, with his arms spread open wide, those arms that became very symbolic to me and had an alternate meaning of "don't trust."

"Everyone must think I'm a real asshole for you to leave all of this life we have," he said.

Exactly.

WILMA

RIGHT NEXT DOOR TO THE WHITE HOUSE LIVED A beautiful woman, both inside and out. Her soul shined as a mom and a wife, as a daughter and a woman. And she looked like Michelle Pfeiffer to boot. It would be easy for many women to hang the jealousy rope around their necks, but they'd surely miss out on getting to know a truly lovely person. She was slightly older than me, by a couple of years, and she had three very cool kids, all several years older than mine.

When I first moved in, we did the dance. You know, watching to see who the other was, what kind of family they were, and life they led. Her youngest was still in high school, and he and my oldest later became very close. It was fall when we piled into the White House. A time when most people were about to shut themselves in for winter, so it was not until spring that she and I officially met. The fact that she

thought Teri Hatcher had moved in next door, after she had seen me one day sitting on the front steps, was a thrill for me. This poor little girl had made it to the Big House, as we say. There we were together in the "fine" neighborhood, in our "fine" houses with big, lovely "fine" yards.

That's when we met for the first time, the lovely yard in the spring. On the heels of the pirate party for my son, I was hosting a backyard party for my daughter's birthday, having a dozen or so kids over. Spectacularly, I had set up a literal playland in my backyard with various games and competitions. It included a dunk tank. Yes, the real kind: big, with a glass front, complete with a lever to strike and a sitting board set above the water. We filled it the day before and, believe me, coming out of the ground, that water was freezing. Off I went to find my victim to put inside.

One of the other games I had brought in was called Big Feet. It's a team-building structure comprised of giant wooden feet with ropes to hold. You have four kids lined up in a row and they put a foot on each one of the giant feet and pick up a rope. The idea is that you have to move together, in tandem and in rhythm, lifting one foot at a time and moving each giant foot forward to the end. Two teams at a time, it's really quite hilarious. The kids loved it.

I was the camp counselor per se, whistle and clipboard

in hand, keeping score in the games, forming teams randomly. I was in my Heaven. This was my purpose, to really work with kids and I felt it strongly for one of the first times in my life. Just before the party started, my new neighbor was standing in her driveway. I went over to let her know what we'd be doing and apologize in advance if there was a lot of noise and commotion.

"Please! Carry on, any way you want," she said to me with a grand smile. "Would you mind if I stand at the fence and watch?"

She laughed.

She then relayed her own stories of the backyard birthday parties she gave her kids, with ponies and merry-go-rounds even (I hid my amazement at the image of that), and how much she loved doing this, too. Our backyard was once part of hers and a very large property for those adventures. She had lived in this same neighborhood all her life and the house she grew up in was just down the street. I had no concept of what that was like, of course. At that moment, we became dearest friends. We are still friends today, some fifteen or so years later, and that fence where she stood and watched was how we came to call ourselves Wilma and Betty. She and I met there for years from time to time, sharing about our lives, just as our namesakes did. The fence was a pretty black wrought iron,

very low and unobtrusive, so it was as if we were standing right beside each other.

It was on that party day, meeting up on her driveway, that I fell in love with having her in my life. We spent the next ten years going through a pretty wild ride together. Six of them in the White House beside her and four down the street in my Escape Home. If someone were to tell us that day how our lives, mine in particular, would end up, we would not have ever believed it. In the meantime, beginning that life in the White House, I felt like I had arrived at my destination. I could live here, and I could fit in. There was a lot I wanted to learn, but I was here, and this was now, and I was ready.

Wilma's house was a marvel to me. There was so much to take in that I spent years looking at it all closely whenever I was over. I learned more from her on putting a house together than any maternal figure I ever had in my life. It was all about the way she was with her home, what it looked like and how it was set up. The colors, textures, materials used, fabrics, and light fixtures...you name it, I digested it all. And the backyard, too, from the type of patio furniture and how it was placed, to her gardens and the flowers she planted every year. Not in a stalking kind of way, it was purely from a learning perspective; I didn't copy, I just observed and began to learn and understand things.

But perhaps the biggest influence she had on my life was how she put *herself* together. To me, she was the first truly beautiful woman I knew simply for the way she carried herself, took care of herself, and her moral ground. I learned more from her about style and grace in those first few years than I could have ever. I don't even know if she knows that or how grateful I will be for that time and what it meant to me. We became friends and adored each other, and it was reciprocal. I did, in return, bring something to her. There was plenty she saw in me that brought her to her own courage, determination, and growth.

Because I was going through challenges, not just with my husband but with his family as well, probably the biggest, or most important, advice she gave me was this: always be a lady, no matter the circumstance. I had explained to her that I was very nervous about going to a house after a memorial service for my friend's sister because my husband's family, particularly his mother, was going to be there. And we were not on speaking terms. "As usual," I had done something "wrong." The only thing wrong was their interpretation. As usual. My husband was not supportive of me in any way in these conflicts; he would rather ignore it and be more concerned where the bar was. I had told Wilma how I was feeling and that I could not *NOT* go.

"No matter what happens, what they say, or what they do, be a lady. Just remember that," she said to me. "Hold

your head high, be there for your friend, and do what 'you' would do."

I took her advice and got through it beautifully. It turns out that death can really scare a person. My husband's mother actually came to me as I was leaving, and very emotionally said we needed to fix things and be back in each other's lives. I used Wilma's phrase in my head many, many times over the next few years. Until the day she had to tell me, "Don't be the crazy one in the room," when I was very nearly falling apart at my husband's hands.

Wilma and I went on to have a great relationship. As neighboring couples, we began to do things together, even vacations now and then. All five of the kids between us loved it, they all got along very well. Wilma's husband, who we'll call Fred, played golf with mine and got into coming-home-late-and-drunk trouble with him now and then, and it was all fun. They were both realtors, and it was Wilma that eventually took me around to see the homes I was interested in. I believe at the beginning of the house searching, I just told her I was curious. But, after about a year or two of the yo-yoing from my husband, I had to sit down and give her the goods.

It wasn't easy. I was highly strung and emotional over it and I knew it was going to be hard to convince her how bad it really was and that I wasn't just feeling it more than

I needed to. As a matter of fact, one of her sage pieces of advice to me was: "Never leave unless you are prepared to never be able to come back." It was also at the point I knew I was not going to get help from his family and friends.

As suspected, she said she understood, but, like everyone else, it was hard to imagine this kind, generous, fun, adventurous man was THAT man. That was his M.O. Be charming as shit to everyone else (I mean, it's social time with plenty of drinks, right?) and when he got home, it all ended and it was boorish time for the family. Rude, selfish, no energy to do anything, kids annoying him, junk food ordered for me to go pick up, snoring...you name it. Anyone who has lived with someone like this knows exactly what I mean.

Wilma took me around to look at houses. I had told her I may need to rent for a period just to get away. I took my daughter with me and we fantasized about living in one of these fine homes. My daughter was like me: loved rearranging furniture in rooms, changing bedding and linens seasonally, looking around other people's houses, and sleeping in other places whether it be hotels or at a friend's. My husband at one point said I had enough bedding to open my own department store.

There I was looking at houses with my daughter and wondering if I could make it work. Wilma gave me my

appropriate space, but not without checking to be sure I knew what I was doing. She was a very dedicated wife, not without her own trials and tribulations and anxieties. She knew marriage could be rough and I had kids to think about. She knew many stories of women leaving and their men dancing into the arms of someone much younger. Yes, that does happen very often, and I saw it up close and personal in the White House neighborhood. But I was different, and Wilma knew that. She knew I was smart enough and this did not look like playing games. I loved her for listening if not for quite understanding. Yet.

My daughter loved Wilma, too, instinctively knew she was a good mom, and just loved to sit and listen to Betty and Wilma talk. But she also came to know, as we all did, that Wilma was not a prude. Off would come the pearls, the hair was let down, tequila shots were lined up, and away we'd go.

My husband and I had taken a trip with them, as couples, to the Bahamas for four days after we had known them about four years. It literally began raining hard the minute we arrived and did not stop until the minute we got back on the plane for home. By the second day, what is there left to do? We hit the outdoor bar around lunchtime and put back a few. The men were winking at each other like, "Hey, we're gonna be having some fun later." The music was loud and fun, and we were all laughing and letting go.

Suddenly, Wilma declared she was going to climb to the high tower in the water park zone, the one where you drop down into a completely dark hole, end up on a slide, and shoot out at the other end into a great big pool. She did not wait for an answer to: who's going first? She marched all the way up and jumped into the hole, feet first. While I endeavored to find her second shoe that seemed to be missing, she proclaimed she was going to jump into the ocean for a swim. I think that's the moment my husband was in love with Wilma, too. But, remember, it was raining for days and with that rain comes wind; with that wind comes waves. Fred took her back out of the surf and we laughed the rest of the night about how she did not make it to dinner.

We still talk about that trip, Wilma and I. It was also the time we planned on her son marrying my daughter. We could only dream. The problem about that particular trip was, my husband had been clean and sober for about eight months prior, and the day we arrived in the Bahamas was the first time that he had a beer. Yes, it was fun that trip, and no we didn't go all out every day, and no we did not pressure him, he just decided he couldn't do it any other way. None of us said much about it. He had been to rehab, for the first time. He had had no choice. It had gotten much worse.

Much worse was I had to lock myself in the guest bed-

room with both kids and the dog, because my husband was completely out of control down in the living room. On a Christmas Eve. It may have ended differently if Fred hadn't come to rescue us in the middle of the night.

CHAPTER FOURTEEN

THE HOLIDAYS

TIMES HAD BEEN STRAINED, WHAT WITH THE UP AND down, back and forth habits of my husband, but the kids and I were simply trying to live some semblance of a normal life: friends, family, and dinner at the table with homework, exams, and school activities. By then, my daughter was loath to bring anyone over, but my son enjoyed bringing in the nice group of kids he had become friends with. It did, in fact, become a very cool time for me too to see all of the kids and be able to provide them with a fun place to hang out when it was just the three of us. Of course, there was plenty of good food as well. I loved making food for hungry kids and it did become one of the things I would always enjoy, cooking for kids who were hungry or in serious need of nourishment. I knew what real hunger was after all.

The White House, the house I cried over finally getting

and setting up so beautifully, was both a source of great pride and pleasure, and a prison full of very dark forces. Was I being held prisoner here or was I chaining myself to it? That was yet to be determined.

When we first moved into the house, Christmas was only a couple months away. My husband and I had been so excited about hosting old friends and the new ones we were making in the neighborhood, within this big lovely home to celebrate the holidays. The only thing to do was have a party. A great big party, done to the nines. He and I were really very good at giving parties and, just as in business, we were a great team working together for success. He was music and drinks and most of the guest list. I was food and invites and setting up the house (well, we both were on the last one). He was very good at making the house so welcoming with the right lighting and everything in its place, really looking fine. Don't get me wrong, I was no slouch, but he had a knack and we worked well together. There were plenty of brand-new holiday decorations brought in and we did a theme of *The Nutcracker* whereby we had a range of them from the very small to five-foot tall. They were grouped in clusters around the main floor hall and living spaces. Added in were a few groups of snowmen and various other glittery puffy fabled creatures gathered on tables, and plenty of garland. It was like a fairy tale and the kids were in love with it all.

We had lots of people, it was a dressy affair, and we hired

a caterer to walk around with snacks. There was a live musician nicely set up in an alcove to play soft guitar. So, so wonderful. It had snowed that day and the street looked like a winter wonderland. The fireplace and candles were lit, the different rooms were set up cozy for all kinds of conversations, and we managed to get the finished basement ready with a pool table and tabletop shuffleboard by then. Naturally, a large bar occupied one end of that room. Later that month, when we had his family for Christmas dinner, they sat in the living room and someone commented that it was like a Norman Rockwell painting. I looked around in awe at all the decor with the gorgeous new furniture I had chosen for the living room and felt so blessed and so happy. It did look like a Norman Rockwell painting. And it was mine. And it was real. Picture perfect you might say. I remember our first summer there after that, I walked all the way to the back of the backyard, stared back at the house, and said to myself, "Wow, I own this." That was the beginning of the White House.

Christmas Eve a few years later I locked myself, my two kids, and my dog in the guest bedroom. My husband was downstairs in the family room completely out of control. He had the music up way too loud on his stereo that had giant speakers sitting on the floor in front of the coffee table. On it sat a giant bottle of vodka. He was also likely high on drugs, but the amount of alcohol he consumed was enough regardless.

When the kids and I first went into that bedroom and cuddled on the bed, we talked about how this was not going well and what to do. They were both in their early teens, young in their age, old in their experience. My husband got louder and louder, He was belligerent with his own voice on top of the music, taunting us from downstairs. He was good at that. At one point, my daughter had gone down to the living room herself and begged him to turn the music down; she was crying as she told him it was scaring her. My husband's response was to turn it up as soon as she turned and ran back upstairs. Eventually, my son just wanted to go to sleep and we were three of us in this crowded bed. I was not going to be able to sleep; I had to keep a lookout for worse to happen. So while he closed his eyes, my daughter and I just got more frazzled and worried. It did not stop.

Eventually, I called and left messages for two of the main people in our lives and the closest to my husband, his brother and his best friend, who was even more like a brother to him. They did not answer—it was Christmas Eve, and late, maybe one or two in the morning—so I left a voicemail. In it, I quite specifically said to please help us and explained the situation, that I would not be calling if it wasn't urgent, and my kids were crying and scared. I had a thumbs up from my daughter for making these calls.

Not only did neither call me back in the morning when

they got the message, they called my husband. And what do you think *he* said? I believe the two I reached out to had called each other, and then one of them was delegated to call my husband. They left a message for him and got called back when he woke up.

"No, no...no worries! Everything is fine! We are all up and about to open Christmas presents," he said on the return call.

Or so he told me when he came to get us all up. No doubt leaving out the part where he would have added: "You know how she is." I did hear that many times during his "excuses" stage. At no time did either of the two I called try to reach me or the kids to see if that was true and if we were alright.

But that night locked in the bedroom as we were, somewhere around 3:00 a.m., with all of this still going on downstairs, I called my neighbor. I called over to Wilma's house and prayed someone would answer. Their daughter did; I was crying on the phone asking her to get her dad to help us. I slipped down quietly and unlocked the door for him and ran back upstairs. Almost immediately, he came in, dressed, if not a little bleary-eyed, and walked on into the family room.

I heard him say, "Hey, what's going on dude?"

My husband answered in a surprise voice, "Hey! Come have a drink. Good to see you!"

Fred did. He sat down, suggested they should turn the music down and have one, so my husband did. Then, Fred suggested that they go to the basement room and not wake anyone up, so my husband did. After the drink, Fred said maybe he should go to bed now and my husband did. Then, my neighbor slipped quietly home. And I never, ever forgot what he did for my family that night. He is still a good friend and very much like family to me and the kids to this day, one of the very few I kept from those days.

The next morning, which was literally only a few hours later, my husband got us all up and let us know it was all okay and we were going to have a nice morning opening gifts. Away we went with it. Like nothing happened. Certainly, no apologies. He was busy making sure we all had smiles on our faces to match his. The thing was we had all spent a great deal of thoughtful time on the gifts we chose that year and had been so excited about opening them. It is very easy to get caught back up in the moment when it all appears to be fine. Underneath, it simmered for me, like a lit fuse attached to a long wire. It did not occur to me to not let us have a nice Christmas Day, and by then I was becoming an expert at floating through normality for the kids' sake. For my own sanity as well.

The next Christmas came, another time I remember it being very bad, and by then I am sure I was certifiable for having stayed. It was when his parents had distanced themselves from us (me) and I had asked if we could stop at a friend's for a drink and some cheer on Christmas Eve. Our kids were friends with theirs as well. My husband didn't want to, so he stayed longer at the office than he needed to, although it probably was bonus time, and I knew it was on purpose. When he finally walked in, in no particular hurry, he took his time to get ready, and then we finally went. Our friends had actually turned out the lights by the time we got there, we were so late. They did welcome us in and we stayed for a bit. On the way home, my husband again tried to pick a fight with me; I had not bit when he was pulling the stunts earlier, and he finally got to me. The way it usually went. Once in the house, I threw some gifts onto the floor in the living room where he sat.

"Do whatever you want," I said to him.

I then went into the guest room and stayed there for a while, later finding out that my son had spent the evening sitting on the floor in his closet. My daughter finally got me out of the room. I went down with her to where my son and my husband were waiting, with the food I had made for us to have late (still working that Christmas Eve tradition) and we sat down, albeit glumly, to carry on.

The next morning, the very special gifts we had taken great care and time with, always important to us, were opened. We gave it the excitement the gifts deserved and pretended like nothing had happened. Later, I overheard him tell my daughter that none of what I say about him is true. He was assuming, but what else do you do when you are very guilty for such things? The fact was I never said anything to them other than things like, "Be careful here."

"Your mom is crazy," I heard him very clearly say to her in a very serious way.

That had become the norm for us—pretending everything was alright after one of his bouts. It was not much longer before I finally had enough and was ready to go. That, well, that would take him bringing the drugs into the house.

TEENAGERS AND DANGER

NORMAN ROCKWELL WAS DEAD AND LIVING IN THE middle of Fine Suburbia. Somewhere around the time both kids had entered high school, when we were still in the Fine White House in the Fine Neighborhood, and they had made many great friends in the area, our lives were about to take a very big turn. It was the beginning of a few more houses to get through, in search of something safe.

At that point, I could no longer ignore the fact that something had to change. I knew it was not going to happen until I moved out and forced it to. There just so happened to be a house available for a short-term rent literally down the road. It was big and had plenty of room for us, albeit a tad outdated and odd. Ugly, really. But it matched my mood. Strange layout and a cold atmosphere, but we would

each have our own bathrooms and they could have their friends over and I could, for the first time in a very, very long time, sit on the couch and actually read a magazine, cover to cover.

I tried to make the Rental as homey as I could for the kids, but I lived like a monk in my expansive bedroom with an old cheap bed we still had from the very early days and nothing else. This room faced the back of the house and through its windows at night, from that creaky, moldy-smelling bed, I could see the tops of three great pines in a dark silhouette. Every night, I went to sleep looking at those treetops and said goodnight to my "Watchers." That's what I had named them. Focusing on them, I somehow felt secure and protected during a period of great turmoil. Being minimalistic in the rental afforded me the opportunity to scale back my outer lens into the world and look inside. My husband was sending an average of thirty or more texts daily with rude and crude harassment. So, every night I asked the Watchers to keep me safe.

Turned out it was the best thing that could have happened for the kids and I, getting back to a simpler, quieter time. The Rental began to have laughter in it, the soft un-anxious kind we used to have what seemed like moons ago. My only goal at that time was to keep them settled and through school, and not embroiled too much in what was going on back at the ranch. I continued to do my Pilates

classes at a small local place with Wilma. One day, maybe a few weeks in at the Rental, the bottoms of my feet became so painful that I could not walk on them; I could barely stand. I never had physical ailments or issues, I remained faithful to staying healthy and was very active to stay in shape. I am a bit of a freak when it comes to nutrition as well (you will likely never see hot dogs in my fridge).

I was barely able to breathe, as I stood against the wall at my Pilates class where the instructor wanted us to roll our bare feet back and forth on one of the foam rollers. You know, the ones that are rock hard and hurt just looking at them. I have no idea why they call them "foam," but anyway. I hid my pain and my tears while we were facing the wall.

Studying Caroline Myss, in particular her book, *Anatomy of The Spirit*, helped me tremendously. I came to understand that it was the parallel of, or the reaction to, "walking away from my marriage." It hurt. Believe me it did, both inside and out, physically, mentally, and emotionally on all levels. But I was my stoic self in the Rental. I had always said to my husband that if those others in my life hadn't been able to hold me back or put me down, he sure as hell wasn't going to. His big problems of alcohol and drugs, they were not going to become mine. It didn't mean it was easy. It surely was not, and I saw the confusion in my kids due to the lies he was telling to cover himself, but I

had faith in them to figure out the truth. They did that in their own time with a little more of "just be careful" from me. I believe that people like my husband can't run away from the truth of what they are doing and do get caught in the lies.

With the kids and I in the Rental, I thought his family was finally going to see what I was trying to tell them. They would have no choice. Especially since he barricaded himself in the house with his drugs and eventually with the drug supplier who came and spent the night with him. I was still in and out of the house a bit because my son refused to leave his father all alone and tried staying there with him, until it got to the point it was just too dangerous. My husband, during that time, had chosen some special things of mine, things that could not be replaced or had sentimental family value to me (very rare) and threw them onto floors to smash or out in the yard to ruin. This was just an example of what he did to let us know he wasn't happy with us living in a cheap ugly house elsewhere. What would people think?

At one point, my sister and I called the police because we believed my husband was capable of overdose. He was in such bad shape, based on the messages I was getting, and we waited by the curb while the police came and knocked on his door. After a few minutes of him no doubt flushing things down the toilet, he answered and

appeared to them in no threat of harm to himself, so they walked away. I never bothered to do that again, call them in, but I was glad for my kids that I did it that day. I was tremendously scared for my husband at the time. By the time his parents and brother had managed to get in there themselves, either that day or within several, he was in a chair in the living room, a real freaked out total dirty wreck. I will never forget the text message I received from his brother.

The text read: "What did you do to him?! He said you were here and now he's a mess. And I now know you lied about him giving you some sort of STD when you were in Vegas. You are a liar, just more of your crap, he said there's no way that happened."

I had been with my husband, our business partner, and his wife on a brief trip to Vegas. The company paid for these little vacations for the four of us, meetings as they were. My husband was drinking steadily for most of it, but loved, and was good at "the tables." Shortly into the trip, he began not coming back until the middle of the night, sleeping in and starting again the next day. I found text messages he sent to his brother. They were basically about how hot the women working at the tables were and about him taking pics from under the table of certain "parts." He even offered to send some of the pics. There was no appropriate response back that I saw. Who knows what

he was doing until all hours of the night, but I ended up with an infection of some sort in a rather delicate area.

Sitting in the Rental, I stared at the text message I received in total disbelief at that point. They were still trying to make it not what it was? Licking their own wounds? Wanting to place blame on the scapegoat that I had always been, choosing to still believe the lies he always told about me to cover this up? Unbelievable.

I had had it. I somehow was not angry, not hurt, just done with trying to make someone understand the truth when they didn't want to see it. This was a battle I had for quite a few years with quite a few people. Yes, I must have felt despair, must have been mad, but really, I remember just deciding to ignore it and walk away. I knew firsthand what it was like to be suddenly aware of, or in the throes of, what was happening: terrified, confused, unsure. I had said he was their problem now, and I meant it. Let them learn, let them see, let them figure it out. They had serious work to do to help him. Me, I could go out and play in the sunshine.

A few hours later came a different text message: "I need help. Can you please come and help me?" I did answer, and I did try to help him. I did not refer back to his previous message. I did not retaliate. I just helped. I can never in good conscience tell my kids to be who they are and not

do things they wouldn't do just because someone did it to them, without living it myself.

Whatever I wanted to do, I could do. I was free for the moment. But the family and best friend were about to embark on that long, hard road with my husband on a very slippery slope. I hoped they could get him to where he needed to be. That was in June right before my fiftieth birthday, something my husband and I had made a plan for a while back. We had reserved a cottage out on the east coast, the place where one of my favorite chefs filmed his show, taking my sister and a few other family members and good friends with us.

I did spend my birthday there as planned. I was determined to while he was in rehab in Arizona. All I could think at the time was that I would never have thought this was where I would end up at fifty—on my own and starting life over—after all the years of building a life. Never mind amid all the planning we had done to be free now to travel together at this point. The concept of now doing that alone was a very scary thought and my mind whirled but refused to be brought down by it. I tried to focus on the idea that maybe, just maybe I would be able to do other things, in the way I had always wanted to.

While in rehab, the kids and I holed up in the Rental (it was a hole), my husband reached out to us a great deal.

He managed to get us down to visit, hand us each a letter full of hope and promise and ultimately got us all back together again once more. It took all his willpower to focus solely on himself once he was back, and everyone gave him the room he needed. We were living all together again, back at the White House. Norman Rockwell had returned, a slightly worn-out version, but he was there. Family dinners, fun with the kids, a whole lot of reading and no booze. Not a drop in the house. I had no problem staying away from it; it wasn't really my thing and the odd glass of wine I would prefer to save for a moment out with a friend would be no problem. It was welcome relief from the past, having to sit through and share two bottles just at lunch with him. Too many times it had been easier to do that than have him stomp off picking a fight if I said no. Spouses of alcoholics know exactly what I mean by that.

My husband made a lot of promises to get us back while he was in rehab. Yes, the kids were happy, but I was wary and so was my daughter a bit; she was the oldest. My son just wanted us all back together again in the White House. That was "home" to him. So, my husband moved us all back out of the rental with a month left on it. It was the place he had been forced to realize we preferred over the way he was behaving. But I had conditions first, and it was promised in all seriousness to me. "No problem," he would say to me and let us all know how much he meant it when he made his promises to us. He made three of them.

By the third month in, he stopped executing on said promises. At four months in, he had forgotten he made them and by the fifth month, he denied ever making them. Insert larger sigh here. The wind was going out of my sails. I felt like a stranger in my own home, wandering around without purpose. I was on auto-pilot and I knew it, but hope had been given to me and I wasn't ready to hand it back.

The final straw was to come the following year, on his fiftieth birthday, the year after mine. He would get out of control once again, this time bringing the drugs into the house. He was caught, I told him to leave, and then he was packing but not leaving because this was his house, the White House. Instead, he told my fourteen-year-old son it was okay to do drugs. Just because his mom didn't do it didn't mean it was bad.

On to the next house. This one wasn't working either. In fact, the bigger, better White House, the one I thought I loved so much, was much worse.

STONE HOUSE

I BEGAN LOOKING IN THE NEIGHBORHOOD FOR another place to rent. The kids wanted to stay close and I wanted to as well and one day I saw a gift from Heaven. There was a house just down the road a bit that was on a side street taking a shortcut around the neighborhood. Many times, I had driven down that street and always remarked to myself how wonderful that house was. Of course, by then I knew what was around and was an expert on wonderful homes. This one truly was.

It was charming and lovely, not too big or outdone like most in the area, but a very nice, classy place, fairly new. It had a cute little porch space in front of the main door (porches had really become my "love") and a smaller service door on the left by the driveway. That one walked into a large mud room leading to the kitchen and was a perfect place for coats and backpacks to be unslung by high school

kids. But for me, my lovely wicker outdoor rocking chair I had bought myself for Mother's Day and dragged around with me was perfect for the front "perch" as it were. The front of the house had beautiful stonework in soft tones of beige, white, and grey, lattice bay windows, and was framed by tall willowy birch trees across the wide front lawn. It was kind of "cottage-citified."

It seemed I had driven by it about a hundred times and always wondered aloud who got to live in that lovely house. You could just glimpse a large, lush backyard with enormous trees at the very back when you looked down the side. On this particular day, as I drove past on the hunt for a new house, there just happened to be a "For Sale" sign out front and I could clearly see it was empty inside. Immediately, I called Wilma's husband and asked him to get me in to view it. He did, I put my best face forward, and told him to make a deal to rent it with an option to buy in six months. That was at the end of September. The Universe was opening up for me. It may have been a scary moment putting myself on the line like that, as it was an expensive property, but it was a sign and I was determined to get through whatever I had to. It was available for immediate occupancy and so was I.

One month prior was my husband's fiftieth birthday party after which he had taken off for two weeks. No communication. Just disappeared. His birthday party was up north

at a resort. It was a place we had always boated to every summer with the kids when they were young, and the party had been planned for a while with plenty of guests. Except, I was no longer going. He had banned me. In essence, how could he afford to have me in the same room with so many people, including the business partner, that might find out the truth? Not to mention expose his lies about what was really going on. It was not a stretch for me to not attend; I was ready to make plans for myself and the kids and found support from my own family who were ready to help with that.

A couple of people afterwards told me about his less-than-decent shenanigans during it. When he didn't show up at home after that weekend, I had a good idea where he was, and with who, but that remained to be seen. It wasn't exactly hard to find out about all the things he was doing, mostly due to his massive ego and equally large mouth. He bragged, literally, to many people, but he would also do it with me. It would bring him, and us, literally to our knees in the near future when he could not help but let me know what he had done, when he saw that I had missed it.

At the end of those two weeks when he was MIA, I was at home with the kids, making dinner to eat out on the back patio when my husband just suddenly walked in. I did not want to look at him, never mind speak to him. He came in in his usual way, barreling through the door and on the

immediate attack giving no one the opportunity to do that to him first. No explanations, just blather. I ignored him, set the table outside for just the kids and I, and sat down to eat with them.

I will never forget how he leaned out the screen door from the kitchen directly at us and told the kids that what I was doing was the worst thing you could do to someone, to not let him sit with us and have food. It made me want to spit. The kids were getting anxious and I just could not stand any more anxiety for them. As hard as it was, believe me it nearly killed me to do it, I walked in the house, grabbed a plate, held it out to him and told him to help himself to the food that had been laid out. He did, sat at the table, and spoke to the kids about normal stuff, as I struggled not to vomit. It may have felt hard to do, but I knew the marriage was over and very well knew that in the time it was going to take to transition, I was going to have to suck it up until it could happen. That meant getting through it without upsetting the kids as much as possible. Our new home was not far away. I was the adult; I was not going to be the crazy one in the room. I was in the "advanced" class.

There was a woman who was in his life before me, way back, the one that stopped calling when she found out my daughter was born. Well, she had come back in the picture, just before I left the first time to the Rental. She managed to attach herself while I was in it and all through

my husband's rehab. Apparently, as I suspected, she was around also while he was missing for those two weeks. Downtown Toronto stays, huge liquor store purchases (I saw the receipts) and the rest, who knows.

When the kids and I were back from the Rental, and my husband was still sober after his first rehab, this woman had left a very drunken message on our house answering machine and it said enough. I didn't tell him, but I messaged her, called her a skank and told her to leave my family alone, and we were trying to work things out. Her only response was, "Oh, it's you," and launched into a diatribe where I gather he had done a good job lying to her as well about what the "real" problem was, "me." I ended the messaging, sending her a photo I took of him in the house just before rehab. The photo captured him looking a complete and horrible mess, glassy bleary eyes bugging out, hair wild, filthy robe on, I mean utterly disgusting. She did not believe it was him. Neither did I. But that was the harsh reality.

I had told my husband about my exchange with this woman, and his only reaction was to be angry at me for sending her that picture of him. I am pretty sure I found out then that he had actually stayed in touch with her during rehab, while making promises of love and commitment to both the Center he was in and to me and the kids. But was it really going to matter to me at this point? As far as I was concerned, they could have each other.

Having dinner at the patio table with him, I was literally sick to my stomach looking at him. He knew it was going to be a rough time and likely was not going to go well for him, but he decided that he was not going to leave "his" house. He let me know that if I wanted to "end us" I would have to be the one to leave and show the kids I was the one destroying the family.

For me, it was all just too surreal. But it had to be done and I had to go on. It was over. Nothing could ever happen again that would make me stay with him. Just looking at him made me burn inside. I truly questioned how I could have ever loved this man. And I was on my own, that much was clear, albeit with support from my side. I was not going to get any help whatsoever from the people of influence in my husband's life. The Christmas Eve story proved that. Not even our business partner, a last resort reach-out, had called me back, but simply phoned my husband instead even after I requested to be heard first. It was the very next week after that patio dinner that I drove by the "For Sale" sign on the Stone House. The home that everyone loved.

I was determined, and eventually I got the deal on the fabulous house. They let me rent for six months with full purchase of the house afterwards. The rent would go toward the purchase. I went to my husband, demanded he give me the six post-dated rent checks, and agree to help

give the funds for the purchase at closing. I made sure it was in both of our names. We would have to spend a great deal of time on dividing later if that's the route we ultimately chose. He had no choice after what he had pulled on the kids and I while I was working on a new place.

It was my sister's fiftieth birthday, in early October. She had planned a trip to Las Vegas for her birthday for a few days with her son who I was close to, and her boyfriend. She invited me to go and I wanted to make plans to do a show and a nice dinner for her. I really, really wanted to go. I had not been away on my own for so long I couldn't remember when.

I begged my husband (not for me to go, I could do that if I wanted) to please, please take care of the kids the right way. I asked him to be good with them, no crazy stuff, just hang out. I let him know just how much I needed this. He agreed, wholeheartedly as a matter of fact, and promised me what I asked. I booked the trip and got very excited. I was going for four days of sunshine, shows, and spectacular dinners.

The day after I arrived in Vegas, the first full day there, as I was laying around the pool with a good book, I got the message. My kids were in trouble and it was bad enough that I had to spend the rest of the day trying to get a flight home. I was able to for the following day. My little getaway

was over before it began. They had gotten to relative safety but were hanging on for me to get home. I was not out of the driveway on my way to the airport when my husband had placed the call saying that he was on his way to "pick up." My daughter had heard him and asked where he was going. He was sitting in our bedroom and he laughed and said, "To the drug store," with all the mirth written on his face. This is, no doubt, what will remain in her memory. She seemed to understand what he meant and let's just say she was not as amused as he seemed to be.

He immediately went to pick up his drugs around the corner at a coffee shop parking lot, clearly pre-arranged. He came back, overdid the drugs while drinking gallons of wine, and late into the evening began to terrorize the kids because of his hallucinating. My son was with a friend in the basement who was going to sleep there that night, and my daughter was in her bedroom going to sleep. He burst into her room and said there were people on the roof and they were trying to get in and couldn't she see their legs dangling over in front of the window? My daughter is like me, basically afraid of the dark, so she did not even look, she leapt from the bed and into the hallway full speed. He kept on about it and she finally figured something was really wrong, so she went into the basement to get her brother. My husband followed her there, wine glass in hand, and ranted to everyone about the people on the roof. Which there weren't any of course. They told him to call

the police, but he had a reason not to and he warned them all not to open any of the doors or go out there.

The kids did figure out what he was doing, the booze and the drugs, and they wanted to go next door and get Wilma's Fred. Their dad was scaring the crap out of them and my daughter of course was very concerned about the friend that was over. My kids, sadly, knew things about my husband's situation, but she rightly determined this was super bad. He would not let them open the door, so they called his parents. His parents lived in a town almost an hour away and it was very late by now, but my kids explained the situation and the parents drove to the White House, arriving probably after two in the morning. They calmed my husband down and put the kids to bed. The next morning, they took my kids with them to their home. The problem was, they also let my husband come, too. By the time they all got settled at my in-laws I was receiving the first news of this and making arrangements to get back. When I did, the kids were home and he was not. Thank goodness.

Not three days later, I was signing the deal for the Stone House, making arrangements to move in, and never again in the same home as my husband. We were finally free.

Part Four

BECOMING

CHAPTER SEVENTEEN

TO BREATHE

I SLEPT LIKE THE DEAD. FOR MANY, MANY NIGHTS. IT was the first thing I did when I got to my new home and set it up. I slept like I hadn't slept in a very long time. The front door was locked and no "body" was going to make its way into my bedroom, no person smelling of drink—the kind that is sour and reeks, and not just from the day's, but the past's intake. No one snoring all night, then for hours in the afternoon. No, no, not here. Not in this bedroom and not in this bed.

In the Stone House, there was warmth and softness. Fresh breezes and sunshine through the window, and quiet. So quiet. The kind of quiet you can wrap yourself in and stay there. The kind of peace knowing your choices mattered and that you would be able to pursue them. The kind of sanity that comes from getting enough sleep and able to embrace the day in a positive way. The kind of place with-

out the fear that at any time someone could barrel their way through the door and take over, making you feel small and weak, and that you didn't matter. Or leave you waiting for endless hours having to rely on them. No more. Not there. In this house, I mattered. Finally.

The Stone House was just so lovely to work with. There I was feeling a bit of an expert at doing that after the homes, cottage, and even the boat. I went to work swiftly; this had been a bold move and I wanted the three of us to have a stable environment and routine as soon as possible. In a week, it looked like I'd been there over a month. Within the first few weeks, it looked like I had been there at least six months. Most of all, it was simply beautiful to me.

As for the house itself, it was a fantastic home with wide, full windows opening on both the brilliant green lush backyard and the lovely view of the street. The kids' bedrooms and the finished basement, perfect for them having friends over, were set up just the way they liked. The front living room was my oasis. It was my private space, with soft white couches and a big fireplace, and a great bay window looking out onto the front gardens and not-too-busy street. It and my bedroom were very Zen, with colors of soft beige and light green, atop dark rich-colored furniture, all new. My expansive bedroom had a set of doors opening onto a small Juliette balcony, looking over the backyard from above. The kitchen in this house was cozier,

prettier and set up to have, at its center, a lovely solid wood table for family gatherings. I never covered the windows at the back of the house but preferred to keep that gorgeous green view wide open. You could see some of the house behind it and I often smiled watching a couple and their young kids have fun on their back deck.

It was hard not to show how happy I was there, how happy I was to be free. I was thankful to be choosing what I did and how I did it. Not to be discounted, and perhaps most important, was the laughter. It started slowly, but as time went on, we three (and the occasional friend of theirs) would wind up around the kitchen table, meal or not, and just laugh. Telling stories, sharing stories—we just felt relieved and were beginning to feel relaxed. It used to be that way with me, but I had long forgotten.

At some point in the last few months, or even the last year, when my husband and I were still living together, it came to me what an angry person I had become. So angry, so negative, so down in the face with sadness and the angst of it all. I realized how argumentative I was, likely always ready for the inevitable fight or disgust, whichever came first. It was always there just below the surface. And so was the standing on the tiptoes of hope when you don't want to admit there isn't any. We tried, we really did my husband and I, only sometimes maybe, but the truth of it

was staring at me in the face for so long and I just didn't want to give up.

But that truth had been carrying me further down a path of inescapable pain and anger. I never realized the full extent of it until one day, near the end, when I did not even recognize myself in the mirror. Who was this person? Who on earth was the woman with the frown stapled on, the glazed eyes, set jaw, and eyebrows set so tight staring back at me? I had only been looking sideways at myself, out of the slanted corner so to speak, and not facing the mirror fully for a very long time.

Maybe I had thought that if the bad stuff went away and things got better, I would then look full on and see the real person, the happy, intelligent, sensual and witty woman who was truly inside. I would see again the woman I was when I met him, and in our first great years of marriage. Maybe I had forgotten about her and maybe I didn't want to see who was there now. That uninhabited place of limbo, neither here, nor there. Maybe I didn't like to admit fully what had happened and wanted to believe it hadn't hurt me as much as it did. I don't know. I just know that one day I took a good look, straight on, and was horrified by what I saw. I was not this woman; I couldn't be. At that moment, I felt tremendously lost and needed to find that other woman again. I badly wanted her to exist again. I couldn't imagine what my kids saw

me as, but I was sure it was a distorted version of the real me.

Once in the Stone House, things changed rapidly for the kids for the better, and I began to do a lot of things to help bring that joy and life back into myself. I spent a day in the sunshine planting roses in my front garden, a full sensory experience, for the simple natural beauty of it. I explored the neighborhood slowly while walking my dog and casually peering into houses, my personal and private nirvana. I learned yoga. I mean "learned" it, took the time to choose a great instructor on video and really listened to his language and what he was trying to teach me. I started slowly and felt I was getting back in touch with my physical body almost immediately, while realizing how disconnected to it I had been. A numbness you could call it. The calmness was helping me through the tough times that were still haunting me from my husband who was harassing us. One of the first things a dear friend noticed was how my face had "fallen'" was the way she put it. She meant it in a good way. She thought I was losing the tight pinched look on my face and youth was emerging again.

Sitting at the dinner table, there was no alcohol or wine, just good conversations centered around the kids, their friends, their school life, etc. The chats really were all about them and the friends that joined us, and not about what the parents do or are all about. It wasn't selfishness;

it was just their age. Having someone to keep that door open and be honest with them, not treat them as children, to really listen, was very important. For all of us. It was gratefully received by them, but it earmarked a path I was going to later follow. My kids were entering into a great part of their lives with the freedom that comes with a driver's license and fun friends. I let them have it. So, we laughed and talked and ate great food and stayed at that table and they knew they were loved. It was the most important thing at that time for me.

That first year in the Stone House was all about giving them a solid and safe, stable life, as much as possible with teenagers in high school. Yes, there were parties, but at least they were at my house, and in a fun way. They deserved that. My kids were very brave and indescribably open and honest about the whole situation. They wanted this to be a good home for them. And maybe, just maybe I finally had a home I had dreamed of that could be that kind of place forever for me, too. I did not mind one bit that I was alone, nor was I concerned at that time how long that would be for.

The house, oh my! Didn't I just get the house that everyone said to me afterwards, "You got that house?! I love that house, it's my favorite!" Indeed. The kids and I were four years there until I woke up one day and saw the Stone House as my "Escape Home," and that I had gone from

zero to ninety, from Norman Bates' poor relation to smack dab in the middle of Stepford, and I couldn't breathe. But many things were to happen first, while living there. By then, I should not have been surprised.

TO DREAM

AFTER THE FIRST NINE OR TEN MONTHS, WHEN THE kids were pretty settled in our routine in the Stone House, and the world was well into the second decade of the millennium, I sat back and took some time to really think about what I wanted to do. Quite specifically, what I had no more excuses for "not doing." My daughter had pointed out to me what she felt I needed to hear, after I spoke again about wishing I had done the writing I always wanted to do. She was right; I did.

"Stephanie Myers was at home with her young kids and managed to write a whole great series," she said quite emphatically. It was the vampire series.

"Yeah, but she didn't live with your dad," was my only way to reply to her, but to myself it was different. OK, here I am, so what do I do about that now?

I had some ideas and decided that I had the perfect house with the best space for privacy to write; it just came down to what to start with. I went online and signed up for a correspondence course on Writing Stories for Children. The children's book might not be the first thing I would do, but it would be great practice, plenty of applicable learning, and would let me know how I was doing with my more-than-rusty writing.

Being an author had been my dream since my last year of high school. I was actually singled out as a great writer with lots of potential. Very few people knew that about me. I never forgot that dream; I just figured there were other things to do first, namely a successful career in sales and raising kids. That diploma I received rather quickly from the correspondence course brought me a final grade of 96 percent and highest honors, along with the courage to dive in. Throughout the course, my son would watch me in the kitchen doing the work, laugh actually at me "doing schoolwork," but ultimately expressed how proud he was of me when I received my final grade in the mail after the exam. It was a pretty big day for me, but his words meant more to me than the letter. It seems you do get back what you give.

Who knew, though, that my first publication would be in business? Yep, I decided to take a friend's advice and ultimately joined a new publishing company that was pro-

moting books strictly to give value to people. The fiction work would have to wait. I thrived in it, as I had in the course. Then I hit my rhythm. In two years, I had two books. The second came about with a co-author, the editor on my first one, and a young woman I had become very close to.

I had two homes. I was determined to still have that life I left and bought a lakeside property in my own hometown. And I had two semi-happy, semi-adjusted kids. If anything, they were pretty impressed with my dedication to building a new direction, or purpose for myself.

I even started seeing someone. I had met him right off the bat opening up into online dating. I think it was eHarmony. It was back when that whole thing first started and was fun, not exactly what it has become today, from what I have heard about it. He was a very nice man, who gave me exactly what I needed. He simply adored me. He gave me an incredible amount of attention. The relationship was mostly good, but we were not exactly alike, and it was challenging for me. It lasted a year and a half, but he did not have much in his life and soon I became his everything. I had to let the relationship go. I wasn't finished dreaming for myself and was nowhere near being anybody's "everything." It was time to spread my wings and go out in the world.

That's exactly what I did. I traveled for the first time to

unknown destinations by myself. I took my kids to many great places we always either said we wanted to go or they were curious about. I became "just me." I was busy "being me" and it was the most wonderful feeling. The anger was there somewhere, still taking up residence. The hurt was still inside me, but I wasn't wearing it. It took a while for the hair to come down, for the youthfulness to emerge again, and for that anger not to simmer and take over the whole day, mood, and otherwise. It took patience, *a lot* of patience, forward facing, and just doing my best every day that I got up. But I got up with the option of making my own choices.

During this transition, over the course of the first couple years in the Stone House, my husband threw all kinds of curveballs at us, finding any and all ways to cut us off financially. I say "us" because, in fact, he was starving his own children with his behavior, something people find very hard to believe, but truth can be ugly. My daughter, in the second year we were there, had gone away for her first year of University, but my son was home with me. He and I tried not to let her know, as I needed her to concentrate on the great school she had been accepted into. There was an education fund for that set aside, so she was fine. But needless to say, I had to send my son to one of his friend's houses in the afternoon, more than once. He was close to a few of them and the parents were very kind and always asked him to stay and have a meal with them if he was over.

My son and I became so incredibly close during that time. He knew what his father was doing to me financially, and we just found ways to get through it together.

On one particular occasion, there was an incident that could have been incredibly embarrassing, but I was that wise, tough girl from the 7-Eleven in the desert, and I knew how to handle myself with dignity. There was still a social account at the golf club my husband had joined in our neighborhood. My son had had a junior membership with him there. The bills from any dining in the clubhouse were sent to him monthly; you just had to write down your member number. One night, my son and I decided we had had enough; it was time to really treat ourselves and let my husband get the bill. We went to the club and he and I had just ordered and were knuckle deep in the bread basket when the manager came over and told us we had to leave. He was sorry, but the account was closed. We left. It's a good thing I can laugh about it now. To the young man my son was, still so young but with the eyes of a weary soldier, that night was just an adventure, it seemed. So were the moments he sat in the front window at night in the dark, watching the cars on the street, his attempt at catching the people my husband had hired to spy on us. We never said a word about the golf club after, just carried on. An undeniable, indescribable, and unbreakable bond was formed between us during those days. It has remained so to this day.

My husband had been busy, creating walls and barriers to me with friends and the people who worked at our company, people I had hired. They were ordered not to speak to me or help me in any way, that kind of thing, and he had the power to do so. He even had me followed. I was in my own world in such a big way that I did not notice at first. Being as egotistical as he was, he had to actually call and tell me. First, he sent me messages such as, "Aren't you driving a little fast?" which I ignored until he added in the comment, "after the gym." It came to a head when I took a vacation with a girlfriend on the east coast and two men knocked on the door claiming to be looking for someone, a random name, all the while staring into the house. My husband just had to call me when I got back, to brag how he could still "reach me." He gave me details of what I was doing on that trip, and even named the place my friend and I had dinner at that night, asking how my meal was. I discovered he even had video of me with the man I was seeing, at night in a parking lot saying an amorous goodbye.

That was what led me to finally make a statement to the police. I understood completely what people meant when they say they had ice running through their veins. It happened to me during one call from my husband when he named the book that was on the night table beside my bed. I froze listening to him. Icy waves were coursing through me and I stood in complete shock. I couldn't speak. All of

what he had likely done, how he must have had someone in my house to spy on me went whirling in my mind. It wasn't enough to be followed and continually harassed, but he sent someone into my space? What was happening? Could this really be the man I married? Was he that deep into the drugs and alcohol to cause him to treat us this way? Was he that hard into saving face by proving me to be the "bad" one in the relationship? Or was his ego just that big? He always thought of himself as Tony Montana from *Scarface* and imagined the kind of power he believed he had, mostly due to his money. And he had money, plenty of it. But this? This was too far, and I was not going to go back to wondering every single day what the day would bring at the hands of a madman.

Off to the police station I went, to make a statement. An officer had come to the house to get a full report and there were important questions and a report to make, it was explained, as I was advised they would be putting out an APB for his arrest. I found myself in a small white "rubber room" at the station, the kind that you could not hurt yourself in if you tried. The young officer painstakingly led me through the myriad of details and then finally let me go. I arrived back at the Stone House, my home, around 1:00 a.m.

The law was going to take care of him, but it was just going to take me a long time to get over the fact that the person

was my husband. We were together for over twenty years, but most importantly we grew up as adults together. We had laughed and loved and cried and hoped and wished and dreamed and cried some more. And now, he had been handed a restraining order. He was to never come near me again. These times they were a-changin' as the Bob Dylan song goes. I wondered desperately if I was ever going to have a decent conversation again with him, the father of my children.

TO LIVE

EVENTUALLY, THE SEPARATION AND SUBSEQUENT divorce went through, as difficult and challenging as it was. I mean, honestly, my husband could not get away with his behavior for long. Through it, I was persevering, refusing to be taken down with him, doing the shit-kicking he afforded himself. The time I had spent giving the kids a pseudo-normal place to be around alleviated a lot of that stress he put on us.

It was a sunny home, for the most part, and we had found our rhythm. They were teenagers, which did not come with the usual messes, but we were solid. My kids did not tell their friends much about it. It was good that they kept some things to themselves and had their friends as an outlet to just be free with, without an "explanation." This put an indelible imprint of true closeness upon us three. Not much was going to ever come between us from there

on. We agreed that we'd pretty much been to hell and back, so good luck to anyone or anything being able to tear down the rock-solid foundation we built together.

The kids had been very aware of being followed and the "watching" my husband had put on us. He had decided he wasn't going to go down as the bad guy. He wanted to find a way to prove I was a bad mom, someone who shouldn't have her children. The kids were spied on in backyards with friends having a few beers (or such), on how they were driving, and where they were going. He even tried to convince the kids I was gay, using that as explanation for how "it wasn't him." But what he didn't realize is these were my kids! I had spent their entire lives raising them, getting close to them, and being there for them. Together, the kids and I decided how to handle his actions, but it did scare my daughter, as well it should have. The thought of a report lying around somewhere detailing when she was home alone, for example, was incredibly disturbing. If anything did happen to her, I am sure it would have sent him truly into the deep end. But my husband wasn't exactly thinking clearly, evidenced by how he spoke to her about what was in a video he obtained of her out one night, clearly missing that "video" was wrong.

But for all of his grandstanding, he wasn't at the Stone House with us, and he did not know the trust the kids and I were building together. He did not know how much we

took deep breaths and held out for us. He simply did not know what we meant to each other. Even when we were still all together, he had spent much of his time away from us, solely taking care of his own needs. I honestly believed he didn't even realize how old they were, that they were not young children anymore. And he certainly did not know how we took care of each other.

Early on in the separation, I did have a breakdown of sorts. I finally let it out and stayed in my bed for a day. Prior to that day, Wilma had marveled at my fortitude for getting up every day and putting one foot in front of the other and keeping us all sane. She knew how hard it would have been for her to do that. She had never moved out of her neighborhood all her life and didn't have the parents that I did, or lack thereof. The night I had stayed in bed all day, I sobbed. I literally sobbed my heart out as my son came in with a chair and sat beside my bed. He did not say a word, just held my hand through the night until I finished and fell asleep. The next day, he went to school on a mere couple of hours of sleep and carried on. He did not excuse himself at school or tell anyone there, not a teacher or the vice principal that was keeping an eye on him. He just did his work the best he could.

Later that month, my son jumped on a plane by himself and flew out to the east coast, a two-hour flight away. His dad's assistant was allowed to organize these things for

the kids if it meant they were coming to him. As the plane landed, my son thought to himself, "Shit, where am I and what am I doing?" He walked in on his father, a place he was laying low at, and quite solidly ordered him to stop what he was doing to me. He was not leaving until his father paid what he owed to me, plus what the kids and I needed to live on until he and I got everything sorted out. My son got what he wanted, stayed a bit longer to watch over his dad to be sure he was heading to getting the help he needed, and came home. Job done. An incredible feat for a very young man who sat by his mom's bed that night and simply had enough. He just took care of it. We never spoke of that night, but we always knew that neither of us would forget it.

A full divorce went through, three years into the separation, and it was time to celebrate, with style and gusto. My husband became simply my ex. There was a large final exchange of funds as all accounts got settled. I had actually not taken all I was entitled to, but I wanted it done and tried over the years to make it worth his while to settle. My freedom (and our collective sanity) was worth more to me than the boat or the artwork we collected, the household belongings. But our savings, our properties, and our company did matter to make equal. As it turned out, he needed to have a divorce due to the "moving on" he'd done with another woman. Perfect.

That spring, a flyer had come in the mail for a special

curated trip with fifty people, over twenty-four days, full of exciting adventures. I happened to be looking through it when my daughter exclaimed how one of the destinations was on her bucket list. I stared at her, then back at the brochure, then sent a message in to the tour people to see if we could join. It had a waiting list, had been advertised for a year, and it was coming up within a few short months. Immediately, I sent a large deposit in with my filled-out application. It turned out they could accommodate a party of three to fill an even number of seating. We were in.

It was the first time I really let go and just followed my heart, energy, and desire and had a fantastic time. No filters. My kids will never forget the unique specialness of it. I believe I was guided by Spirit to make sure we all made it onto this particular trip. It heralded a new beginning, full of passionate adventure. I had several people come to me at the end of the trip to let me know that, at first, they groaned inwardly seeing such young adults on the rather decadent, expensive trip, but that they had come to know my kids as wonderful, mature people in their own right, fully partaking in the magic that it was. Little did they know why.

Although mostly older folks, there were quite a few young people on the trip, and a few single ones including two great guys doing the filming along the way. It was a party. I was usually in the center of it. What was especially dear

is that we made very special friends for life on that trip. At one point, after a few days of large laughter, dancing, and assorted tomfoolery, one of the women looked at my son. It was probably after a bit of colorful language on my part.

"Does that bother you, is your mom always like that?" she asked him.

My son looked over at her with a big smile and replied, "Yeah. Isn't she great?"

I had arrived back to me. Now just what the hell was I going to do with me?

WHERE TO NOW?

IT WAS EARLY DECEMBER, A FEW WEEKS BEFORE Christmas and the three of us were in the front room of the Stone House decorating the tree. It stood right in front of the big picture window facing the street. We lived in a neighborhood known for its many homes and hanging lights during the holidays. We were in a great, festive mood. My son was helping me while my daughter was across the hallway from us in the dining room doing schoolwork and watching. She had come home after her first year at a university that was far away and decided to switch to a local one to be with us. Norman Rockwell had taken up full residence again, if not slightly ragged and a little grayer.

We were hanging the tree ornaments in our tradition; each one had a story of who gave it, or where we got it, when, and why. From the Mommy's First Christmas of a woman

in a nightgown holding a screaming baby to a War Memorial, one my son brought back from a school trip, there was something from almost every year, gloriously mismatched. My son told me at that very moment that if I ever moved from here later in life that he would break into this house just to have a Christmas here all together. I could not reply. I continued to hang the ornaments and was very silent as I contemplated what he had just said.

My son had had a hard time with both of the last two moves. When we moved away from our very first home we had when he was born, the Red House, it was hard for him to understand. He had a fabulous room for the whole of his nine years there, filled with his great and precious things he loved so much. Of course, he did; how could he not? Both my kids had rooms right out of a catalog! When we, as a family, moved into that second one, the White House, it became very special to him as well. He had grown even more attached to that one, having bigger spaces that were perfect as he got older, and having great neighborhood friends over. Not only had that one ended for us as well, but my son was reluctant to leave his father behind, which we had to do. Now, no doubt due to the wonderful family times we were having, he began to be very happy in the Stone House, the lovely home that everyone admired. Apparently, he did, too, I thought to myself as we hung the decorations. So, what was I going to do now? I still wasn't sure this was going to be the house for me for my future.

I had the beginnings of wanting to be out of that particular neighborhood and all its pretentiousness. Things had begun to wear a little thin on me, particularly the idle rich kids with no motivation other than driving their parents' luxury vehicles to school a few blocks away.

I did what a mother should do when it's a starry night and just beginning to snow. When Christmas carols are on the radio, the dog is asleep in front of the fireplace, and we are decorating the Christmas tree. I hugged him tightly and said, "Thank you."

At the same time, my life was becoming much more fulfilling. I seemed to be heading into a life and work that reflected my desire for the caring of kids. I don't mean young children; at this point, it was teenagers mostly, but it came as no surprise it had to do with teaching and parenting. Those were the two things I struggled to understand growing up the way I did with the teachers and parents who colored my early years.

The first book I published was a great, short, specialized one to assist millennials on getting ahead in their highly competitive world. The writing itself came from my full experiences in customer service and timeless practices that should not be forgotten, particularly since millennials all talk about wanting to be entrepreneurs (or millionaires). The book was about great tools to bring success.

But that work, or my desire for it, grew from and had begun simply by having truthful, open conversations with my kids' friends and family, the same way I did with my own. From their side, it was mostly at first about budding relationships (what else?!) and such, but eventually the conversations moved on to specifics of work and work environments as they got older. For this, I had plenty of successful experience in and really enjoyed talking about. I love that they still reach out to me today, well into their twenties and in careers mostly, to sit on my back porch and share. When they read my work, they want a debate. Bring it on.

I also loved feeding them, something that would also stay with me for a long time, something that was hugely important to me. I knew what it was like to know real hunger and what that can do to a person's confidence and sense of place. Even for the kids who did have plenty, I took it upon myself to have very healthy food on hand for them. For instance, during their last year of high school, many of my son's friends would gather at my house for the afternoon during spares, under the guise of studying and writing essays. I would insist that they leave the bags from McDonalds "out there" and began stocking the fridge with many small trays of veggies and fruit for them. It wasn't long before they began to learn that they could talk to me about issues they were having. I never judged but always told the truth if they asked. So, when they came in, they

usually stopped in on me first to "talk," and then on to the gaming...er, studying.

It grew to much more when everyone got older and real-life issues became realities. My son in particular would come to me—he always understood he could—if one of his friends was in some sort of trouble, or just needed a hand financially. All of them were treated as my own when they were in my house, including the rules such as no electronics, only conversation at my dinner table. It wasn't difficult; they gladly obliged me for the sake of one of my great spreads in honor of them being there.

In an extreme case, my son had called me one day while I was away in Europe for about ten days on a new confer-ence I had joined. He told me about his friend that had disappeared from his life over a year ago. Out of the blue this friend had messaged asking if he could come over and showed up a couple hours later with a suitcase. There began our journey helping his friend get his shit together and life back. He ended up living with us for almost a year, learning a lot about taking control of his own life and having the responsibility of it, and trying to stay on the right path. All the while I was myself blossoming, or perhaps transforming, into what I felt was important in my life and my purpose. One thing had become very clear: my Stone House had become my Escape Home. A place of refuge, a place of recal-ibration, yes, but it was somehow still attached to my old life.

What I did know when I woke up that morning in my Escape Home and couldn't breathe was that this was not my home. It was not where I knew I was to end up. All of the homes had been set up or centered around what pleased my husband (what it had, such as a "bar") and what pleased my kids (near to what and whom). They were beautiful homes, absolutely, and I had a big hand in choosing and setting them up, but this was different. I no longer wanted a home that had anything to do with my past life with my husband and I no longer wanted to live in that neighborhood. I never felt I truly belonged there, if I had to be honest with myself. The fact that the house was broken into by someone in the neighborhood that my kids knew of (it's not a stretch to believe it was for drug money), was probably the last straw. Notwithstanding was the fact that drugs were running very high among the rich kids in the "hood" who could afford them and had too much time on their hands.

I didn't tell the kids; I just started poking around at homes for sale and by then, after living alone for long enough and finetuning myself on the inside, my intuition was telling me that it was the right time. There was a community, two cities over, that I had once looked into moving to quite a few years back. It was a much smaller city and just that little bit of a farther reach, but it was quieter and had more of a sense of peace and community to it. Off I went to look, and didn't I just find it on the first run? I walked straight

into MY house, a new build on a pretty little street of old and young families, old-style cozy homes and newer ones in many different styles. There was the big "For Sale" sign on the lawn beckoning me in. It was surrounded by streets that looked right out of *Leave It to Beaver*. That was not necessarily a must but a bonus.

It was as if they had built it just for me to suit my new lifestyle and needs for my future, and it was "brand new." I would be the first one to live there, the one to make it a home. I brought Wilma and Fred, once again my realtor; she stood in the empty house just like I had and remarked she just couldn't find one thing wrong with it. Just like I had. In my bones, I somehow knew this was where I was meant to be. And that turned out to be absolutely correct. It had all of the things I needed and wanted including a grand covered porch in the back looking out onto a full ravine with a creek and massive, gorgeous trees. There was room for a huge kitchen table to have as many people as I could feed.

Cooking had been one of the hobbies I dove into while I stayed home to look after the kids when they were born. It always was my passion, and I had organized and conducted cooking lessons in my home during that time, part of my solace, part of keeping my own identity intact. This house, this Me Home, had the most beautiful large kitchen for all kinds of cooking to be done. I was in love. But I had

to get it by the kids. All three of us still made the decisions. This wasn't going to be easy.

They didn't take to it too kindly, and for the first and only time my son did not speak to me—for two days even. When I told them all about it, I had already purchased it. It did not take me long at all to decide and work the sale. It was time to move. My daughter did speak, only to yell at me quite expressively and stomp off. I stuck to my guns. They came around, not too long after really, and even ended up loving it as I did, almost as much. Both kids eventually became grateful for the move to a better community and home. It became a place where I further began to develop who I wanted to be and what I wanted to accomplish. I settled into a great routine and flourished even more, another diploma earned, and the second book written.

My next correspondence course was on Relaxation Therapy, in particular with young people and technology today. I digested every bit of it, earned another high honors diploma and could be found following the kids, any kids that were in the house, talking about what they needed to know. I began to put together workshops for young women, designing a program for them to both learn from my work experience and do the work to help find their own paths based on exploring core values. I held several sessions in my home; the entry fee was minimal. It was more of something I wanted to give, and I loved my little

group of eager participants. They came from many different backgrounds and personal situations but were very equal in my home. More than that, I realized that this made me feel very satisfied.

At the same time, I worked on my second book, a collaboration with my co-author, a wonderful young woman who was the editor on my first book. She and I had sat many a day having real talks about life, careers, and fears facing the future for her generation. I helped her, and other young fresh recruits, navigate serious issues they were all having in the "corporate world" working for a giant company. She, in turn, helped me see the world in a new, fresher, more exciting way and to speak up more boldly about my own gifts. The result was my second book, designed to show how young and old generations could work together, helping millennials navigate their careers, and encouraging more open communication. It was born the day she told me how her relationship had changed with her mom, and how, after spending that time with me, she had begun to consider that her mom had a story, too.

By the time I had moved into the Me House, I had many new friends that I had made along the way, through travels, new work, and just life in general. Every day, I was feeling more and more fulfilled and truly happy about what I was doing. I did burn the proverbial candle, or candles actually, at both ends, but it was exhilarating. I was figuring

out the endless possibilities of what I could do with my talent, energy, and resources, including financially, and of the people I was learning from. I was focusing on living and working by my young self's mantra: "what is right, what is good," which had been etched inside me all along, never forgotten.

It was a brilliant time for me to learn much about myself. That first year in the Me House taught me a lot about where I wanted my work, and in the future, led me to how much I wanted to help others. I was shedding all that I was attached to and it felt so different from what I thought I wanted and what I thought was important.

RELATIONSHIPS

HAVING THE RIGHT GUY IS LIKE HAVING THE PERFECT pair of shoes: comfortable yet fashionable, easy to wear in but won't wear down. They go with anything you wear and fit your style. They are within your budget but look expensive, make you feel amazing just slipping into them, never talk back, and last forever. And, like that pair of perfect shoes, you may have to try a few on before finding the right one.

Moving into the Me House, I got my feet back on the ground with the kids and household organized. Long after getting my feet wet with the first relationship try, I hit the ground running. Time to have some fun, time to not take life so seriously, and meet some interesting people. If a relationship developed out of it, well, that would be special, too. But in the meantime, I decided I was open to dating, to go out and keep it casual. I had no trouble meeting men. My

situation was attractive. I was self-supportive, independent, happy with (almost) no baggage, and definitely in shape for my age. However, sometimes it was just...well...what the hell do I do with this? Some were looking for a mommy. Almost all had exes and kids to support and needed just the "ahem" they hadn't been getting for a while. I weeded those out quickly but did end up having some fun along the way.

But one thing that was "in the way," the only way I could describe it, was my homes. Plural. They are grand, to an extent. My city home, the Me House, was in a semi expensive neighborhood and my Cottage that was far away in my rural hometown had a very large property right on the water. There was also the place I rented in a southern climate for a while where I wrote my books and hung out with some very cool new friends. I knew all of it could be intimidating. I was always at ease being humble about it, not bragging in any way, but still. I would find myself either leaving certain details of them out or playing things down. Sometimes, I did want to show it, in a very proud way. One person I chose was clearly the wrong person to do that with.

"Oh. I see you must have taken your ex for quite a ride." Or, maybe it was, "for everything he had," he said to me as soon as he walked into my house.

He didn't say much after that; you can't talk with your balls jammed down your throat.

There was also the thought: "Gee, I can't give you those things." I didn't need them for that; I could do those things for myself. What I wanted was a companion. Someone to share time, have a laugh, and go out on sexy dates. I saw a post once, with a quote by Brooke Hampton, and at the time it summed me up perfectly:

> "I'm not waiting for a hero. I saved myself long ago. I don't need someone to complete me. I am whole alone. I just want a weirdo to go on adventures with. Someone who will dance with me, kiss me when I least expect, and make me laugh."

I was probably not being too picky, or not picky enough, but it was easy for me to get swept up by someone who was really into me. I must have craved the right kind of attention, because I was willing to "settle" at times when, had I really stepped aside and took a good evaluation, I probably would have not engaged. Thusly, I was very accepting. But I had felt so cheated those last years with my ex, and I wanted to have someone just for me again. I had love, the kind that comes from a true bonding. I called my husband, now my ex, the love of my life, and I still do to this day. I may not have that kind of love again, but I will have love again, the right kind of love. I had to believe that, and I still do. For one, my heart is too big for just me. Two, I love life and live it with such enjoyment now. Why would I not want to share that with someone else?

At times, it was great fun getting out there, for the most part. I learned to know what I liked, disliked, and what "fit." The thing was, I also figured out I was putting forth the wrong language when it came to "my homes." I was the one putting up a wall or block, making it an issue, by virtue of the way I was explaining it, or not sharing that part about me. I was doing the judging for them.

After a few forays, there did come a time when someone close to me said, "You can't fix them." It was a big enough blow to me to sit down and realize I was attaching myself to men who had something wrong, or something off about them. It was nothing tragic but just "things." And I had to hear myself say, "I can't fix them, just like I couldn't fix my ex." There was a turning point for me then, a big realization, and another look in the mirror full on. I wasn't looking for these men, no, but I was holding onto them when they were not necessarily a fit. It was true; I was loving the simple adoration they would give, again holding on to that even though I knew it was not a fit. It wasn't ever a bad thing altogether, but I definitely lingered a bit long, or hoped for more from it. It always happened quite soon after, me being so glad it ended, of course. It did only get better. But I had to learn it first.

One thing was for certain; no one was going to take away my freedom. They may as well move to Siberia than hold me down or hold me back and not appreciate me for

who I was. I knew better, and I knew my worth. That's about balance, and it was going to take someone who felt the same way I did about love and respect. I knew that person was out there and eventually we would find each other. I was not one of these people that come out of those wicked marriages and say, "Oh, I'll NEVER get married again." When I heard that from other people I always thought, "Well, how do you know? How do you know someone won't come along that you would want to be with? Why would you limit that possibility?" I didn't know if it would happen for me, but I was willing to accept it if it did. That much I knew. It was okay if I didn't have it again and live with someone I loved, but I left myself open to that possibility.

Sadly, I had to watch my husband get destroyed by someone who came along after me. He went about buying a whole new family, for the wrong kind of love and the image he wanted to project. A steam train was pulling out of his station fast and it was full speed ahead. All the rest of us could do, after many failed attempts to show him what he was doing, was watch him step so far away from himself and fall even deeper. At least I had gotten out fully by then; it was only a matter of helping my kids through it. I believe that with wealth comes great power, power that you can do one of two things with: you can self-destruct, or you can do good in the world. My ex went one way and I went the other.

But that brings me to the most fundamental relationships, those with my children. It was best that they had a place far removed, both emotionally and physically, from their dad and his crazy world, in the house we were together in. It was the Me Home I was flourishing in. They saw for themselves how happy I was on a daily basis and that, of course, translated to how happy they, too, could be. Hardly a day went by I didn't tell them how happy I was living there now, how much I loved my new neighborhood and my new city. I was at peace. They, too, took great comfort in the new environment and in how much I was able to accomplish with my new projects and how I was doing personal-wise. I finally felt like I was "home." It was something in the air, not spoken; it didn't have to be, that the past did not live there. It just couldn't. All of those feelings were so important to the new growth in my kids. They were still very close to the source, their dad, in terms of knowing what was going on, and never stopped wanting to save him. So, for them, the home became the safe place, the home that they could come into and just be themselves and for a time feel they were far away from the chaos around his alcoholism.

As close as we had been, and able to talk about anything, that did not change. In fact, it only got better in the Me House. One finished school, one kept plugging away at school, but both chose to be at home during those years. We had each other while the other side was out of control,

and that to me was the most important thing. They were young adults at that point, albeit in the very early stages, and able to go into their dad's world on their own. But I always insisted on them not using that other situation as an excuse to make bad choices, and not do what they knew was wrong or hurtful to themselves or others. It was a tough balance, keeping them focused on the everyday and their expected responsibilities, and not going down the path of sadness, loneliness, fear, and self-sabotage because of their father. It took a great amount of courage to watch them go to him on their own, without comment or judgement from me on his current state or antics, only a listening ear when they came in with it. But I did it, it had to be that way if we were going to get along and on with our lives.

What I chose to do was to spend a great deal of time with both of my kids telling multitudes of stories, stories around who their dad was when I met him, when he was a young man, before they came along. I told of who he was in business, what made him so special not just to me but to everyone around him. It was a heady experience for me, and a fantastic ride back in time. They loved the stories. It was really good for my daughter who had avoided seeing her dad for a long time. She couldn't. She didn't want to "pity him," something that was really quite mature in a young woman. My son likely heard more of the great stories; he kept asking me, as this was important to him

in a different way. They laughed so much with me, over the fantastic adventures my husband and I had because of who he was and how we were together. It was just so fun for them and it made them really feel better at times, but, naturally, just a little sadder.

It was good for them but also a double-edged sword. It was like creating a slightly different relationship between me and them; they got to see that their dad and I were truly in love. There was no doubt about that, they could fully see, and how much I had lost. It made my son make a silent vow to himself that he would never move out of the house until I had some sort of a permanent relationship. This I came to find out later, I had always felt it, but let him have that for himself for a while. He hated the thought of me being alone. I think it hurt him more, what I had lost.

THE RIGHT PATH

THE MORE I BEGAN TO EXPLORE AND NAVIGATE MY way through helping others, be it through the books I was writing, the kids I was helping at my kitchen table, or the speaking I was doing in colleges, a very unique form of gratification was arising in me. It was clear how passionate I was about this work I found important when I spoke, helped, or just listened. It came through; you could tell it in my voice, my language, and how I expressed myself. It was my jam as they now say. Quite specifically, I learned how much it mattered to younger people, just how much it meant to have someone actually care like that. It was no surprise at all to me that it pulled me back in reverie to not having had that myself. But the moment came when I realized that this was my success. In other words, "their" success became "my" success, and I was caring for the sake of caring. If I helped just one person, I slept very well at night.

I was likely more eager and excited about my books than the general public, but it didn't stop me from loading up on copies and giving them away. Nothing made me happier than hearing from people, not just the youth but older people as well, about how they enjoyed it or how much it had helped. I knew that this was an important role for me. I also knew I was not done and there were many different avenues I still wanted to take a walk down and through. With great new friends I had made in the warm southern city I had my condo in, I managed to executive produce an independent film. It was fun, I have to admit, and provided my daughter with great experience in her field of study, but knew it wasn't to be my path. I also had joined a rather large group of various distinct businesspeople from around the world that met twice a year in a conference setting I had begun attending. It was then that I managed to become acquaintances with some pretty cool people, those who also loved their job as I did. One was Jim Donald, past CEO of Starbucks, which is only part of his illustrious career. Being in that environment had come about through a well-known thought leader in Toronto I did private coaching with who, in turn, led me to the most influential person I could have had in my life at the time: Philip. Intense and direct, he was a tough son of a bitch with the softest caring heart.

I was in my transition stage, my transformation to become me, after the move to the Me House when I met Philip.

What I didn't know until then was that there was much work still to be done, deep internal work. He was revolutionizing the way we learned about our past including, and especially, about childhood trauma, and all its peculiarities and associations. That's a big sentence, but it was big work. It was hard, the hardest work I have had to do, but it led to the shedding of shame, regret, and blame. It uncovered the most important thing: my truth. He lives by his edict, "Your greatest gift lies next to your deepest wounds."

After I had first met him briefly, I took the plunge and joined a week retreat on the west coast of Ireland with a group of twenty people I did not know. A few more years saw me diving into more of the work he offered. It was about who I was, what I wanted to do, and how my life had meaning. His work on true leadership, his philosophy mirroring my own, was also a big part of that journey. My confidence in what I had to offer others grew.

I owe an extreme amount of gratitude for that, for what Philip taught me to see and understand, and have since brought both my kids into some of his work. It is changing their lives, too, in some pretty amazing ways. With Philip, I found myself wanting to find more of me, to be me, to love me. The right kind of love. It was a very important part of my own growth and fueled the determination of how I could and wanted to help others.

To be specific, though, I had a great routine. I had my city home that the kids were centered around, and the hometown cottage far enough north to be in another world. It was there the kids and I were now spending Christmases. It was incredibly magical at that time of year, always guaranteed to have snow by then, and with its real wood fireplace and country charm it was a great place to rest and eat good food. My special gift for us and extended family was a night sleigh ride at Farmer Bob's every Christmas Eve and a buffet dinner afterwards. Norman Rockwell, move over. I was now spending the summers at the cottage as well.

There was also my condo I rented in the south, and there I thrived. The friends I simply adored, the food I loved so much, the laughter around both, the nights out and days in writing, it was my Heaven. I truly found a great rhythm there, and it was a perfect little home to spend most of my creative time alone writing. My kids were very happy about it all, too, if not getting a little spoiled.

While all of that was going on, our home life was settling in on a rhythm of its own, better than it ever was and better than I expected. The kids and I were finding ourselves in the place of accomplishment and achievement, and even if we found ourselves off course we could help steer each other back. I wasn't the only one navigating changes in direction. My kids were, too.

My son changed the school and program he was in. Being absorbed in the problems with his dad, he had chosen to go to post-secondary in the town where his grandparents lived. I was only a half-hour drive away; it was his comfort. He then figured out, almost two years into it, that it was the wrong choice in program for him and made a move in another direction. It proved to be a very good one. My daughter had put herself wholly into her school program and thrived. She was always the consummate student and gave all her subjects her sincerity, and with great importance. She earned a high honors diploma in less time than her peers and earned a special place in a global society. All of these contributed to successes that were coming as our lives were taking better shape. It was a very happy time but still filled with wonder at where it was all going to take us.

For me, I became a much easier person in the household. I could not be antagonized into getting into arguments very easily and for the most part remained calm in many situations that would have made me pull my hair out not long before. To me, life was good, not much could undo me at this point with the kids, and it was okay for them to have the normal array of issues in the form of sibling conflicts. I was keeping things pretty even-keeled. Friendships for myself and the kids were also flourishing. My door was always open.

I was incredibly proud that all the kids' friends that came

to sit at my table throughout their teenage years still came to see me first when they walked into my house. They asked how I was doing, if I was seeing anyone, and whether I was being treated well because otherwise they'd have something to say to them...gold. The same went for me, as I asked them how they were managing, and if they needed anything. I kept my ear to the ground and came to know who was floating out there and needed some sort of help, and who was maybe heading into trouble. Sometimes, my kids brought it to my attention, or literally, brought them directly to me, but I would also ask one of my kids to reach out on my behalf if something was in the wind. I know they were very proud of that and the respect I gave and earned back.

My role in leadership was forming, too. I realized I knew more than I thought I knew. My ex and I had liked to challenge each other from time to time and I (or he) would say I was the smartest one in the room. Combined with the desire to teach, to help or instruct, it became clear I could play a leadership role in many situations with young people; I just had to decide in which space. I had always held confidence and, with the knowledge I had gained in my career, not to mention how the world was heralding women in business, I had great stories to share. I was becoming a good storyteller. I loved bringing things to life, the incredible moments I shared with the kids about my ex notwithstanding. But, as settled as that life was becoming,

the moving forward was to be halted to a degree for just a bit longer.

My ex-husband was to have one more dramatic moment in our lives.

CLOSURE AND MORE CALLS TO ANSWER

I HAD A BETTER RELATIONSHIP WITH MY HUSBAND after he died than I had had with him for the last several years he was alive.

We got the call, as expected. Although no surprise, believe me it will still shock and jolt and scare you. It meant all hope was gone. There would be no more calls to not answer, as my son put it so well. And it meant final peace. As much as we were seeking it, it meant more that my ex was finally at peace. No more demons. No more black box he had hid inside that he couldn't find his way out of.

My ex-husband drank himself to death. It finally got to him, taking longer and much later than many of us expected, but he was also a fighter, a warrior, the captain of

his own flight. This, too, was going to happen on his own terms, not society's. The kids were told in enough time to see him at the hospital, still alive, albeit unconscious. They, at first, were scared by the wild look of the "old man" under all of the tubes and other sorts of things hooked up to him that were keeping him alive, for the moment. He was not going to survive even under life support. He passed away that day and they saw him in his natural state afterwards and were glad of it.

Me, I wandered around my house the entire day, meandering aimlessly not really seeing or doing, just aimless. All I could say, out loud and with a deep sigh, was, "Oh, what have you done? What did you do?" Around five o'clock in the evening, I laid on my bed and very shortly after I felt his energy pass through me. It was clear as a bell to me that is what it was. He had a cousin in The Netherlands whom he was close to. They grew up like brothers and held a very special bond. I became very close to this man as well. The cousin told me later at the memorial that he had felt the same energy wash through him at exactly the same time I did. I found out it was right at the time of my ex-husband's passing. Did I mention he was the love of my life? It made sense to me that I felt him, his true presence, that day as he passed.

My son came home to me a day or two later; this had happened in another city. He walked in the door, came straight in to where I was standing, and held on to me very tightly.

"Mom, don't die. You're the only parent I have left," he whispered hoarsely to me.

I made a promise to him that no one is able to do, and I went into my room and just cried. For us all.

The previous year I had also begun a very spiritual journey in addition to the personal and business development. It started with curiosity but grew into passion and knowledge and served me well as I further honed into my own intuition. I read the great works by Caroline Myss, actually "absorbed" is probably a better word, such as *Anatomy of the Spirit* and *Sacred Contracts*. The latter being one I heavily related to and understood. It made me feel connected to something I felt deep inside me, something I somehow "knew" but needed to open up, or "see." From there, I began to work with others I had met in my travels on the philosophies, if you will, of higher state or the collective unconscious. It seemed not only a good fit for me but also the right time. I do honestly believe that the script is written for our lives. Don't get me wrong; we make choices every minute of every day, but I strongly feel the Universe will ultimately find a way to bring us what is going to happen regardless. And, no, I wasn't scaring people into thinking I'd gone mad by oversharing, if you know what I mean.

My connection to my ex after he passed away began about

half a year later. Just when you thought it was safe to go back in the water, in walks my son's girlfriend with a message from him. She had attended a psychic that day, with her mother who had hoped to reach a long-lost dear friend. What she got was my ex. As soon as that spirit door was opened, he had jammed his foot in it and wouldn't let go. In other words, true to who he absolutely was, he took over and had things he wanted to say.

My son's girlfriend walked into our house that evening, sat down, and proceeded to tell us how she had ended up with her mother at the psychic's house. The woman who was supposed to attend the appointment cancelled at the last moment, and her mother didn't want to do the long drive by herself. Off they went together. It had taken a great while for them to understand who the spirit was that had come in, but it's natural to try and fit it into who we want to believe it is. The kids and I were passing the food around the table, enjoying a meal together with her, when she then told us it was my ex that had appeared.

The kids and I just stared at her. Silence at the table. It was not a foreign concept, but it came right out of the blue.

"I have a message for each of you from him," she said. "He asked that it be passed on."

Our mouths hung open for a moment, forks in mid-air,

and nobody moved. Looking at each other, we slowly gauged how we wanted this all to come out, wait or rip the Band-Aid off? We sat back and simply said, "Do tell."

What came out was undeniably clear messages for each of us, things that were very personal and close to our heart. This came after a rather stilted way of him trying to explain who he was. The kids were given quite a long message, with several things addressed. For me, it was much more simple, a single message "of love." The kids and I did not talk much about it that night, but it had been recorded and was given to me, so I had a good listen later. That was the first time I heard from him.

About a month or so later, I was in the grocery store when I got a call from a close friend that knew my husband and I both very well. She and I are able to communicate on so many levels with each other. She said she was part of a group of about six ladies that, as a treat during some sort of female gathering, they were sat at a table together with a psychic. This woman simply tapped into whatever came to her. There was a point when the psychic kept looking at my friend and said someone was trying to get a message through. Instinctively my friend thought it was for me after she heard it. The message was given to me on the subsequent phone call in the middle of the canned goods aisle and it was clear it was about my son. I relayed it to him, who admitted he was guilty of what the warning

was about. Case closed. I knew somewhere out there my ex-husband, their father, was trying to get our attention. It was time to do something about it.

CANDLES AND BLACK CATS

I WAS SPENDING TIME AT MY RENTED CONDO IN THE south. A great kindred community, for me a freer place, very artistic, creative, and vocal with a distinct flourish. It was what others call "hip" and "chill." I had decided to look up psychics in that area and get this out once and for all, to have that conversation with my ex. I was sure he was waiting.

The medium I had chosen was a young woman who really spoke to me when I saw her site. I passed over the local celebrity ones, you know the ones the idle rich women of town line up for to enhance lives that were lacking in certain areas. Those psychics were the flashy ones, their site showcasing how long it would take to get an appointment as they were *it* in town, with prices to match their attitude.

But this woman that attracted me was humbly genuine. I felt it in my bones. I felt it in my gut. My intuition kicked in big time. It did not get by me that this was direct guidance; I was in the advanced class spiritually by that time. I reached out, and we set up an appointment in her house. It was so cool to be honest, walking in, and I felt very comfortable immediately. I loved her "magic" elements around the house including the ubiquitous black cat who wanted to attend our session. I think I loved her little stone gargoyles the most. Her smile and humor during our discussions was definitely my kind of fun.

My medium took me to the back of the house to her special room and table. Lighting her candle, she instructed me to "open the door" in my mind with a welcoming light and see what happens, see who wants to walk in. Many did; it was such an amazing experience. As they described themselves, and I figured out who was there, I knew it was going to be a very emotional experience but one that I immediately became aware it was the right time for. My real father was there, someone I had barely known, and it was an enormously comforting feeling. I was able to identify, or rather confirm, who the female presence was that was always with me. I knew she was standing on my right when my medium said she was there. I say "my medium" because that's how I refer to her, mine now for we have since become friends who share about our lives and miss each other when I haven't been to see her in a while. That

constant presence, she pointed out, was my grandmother. Grammy was a strong maternal figure in my life. Nosy, but meant well, and someone I didn't realize how much she meant to me until well after she was gone.

On the second visit I had with my medium, my ex was there before I even arrived. His spirit was in the car with her as she drove to pick up a coffee just before I was to arrive.

"Now you be nice today. I really like this woman, so behave," is what she said aloud to him.

The two of them, honestly, had ended up developing a great rapport together, complete with witty banter and openness. He visited her in her dreams and spoke to her out loud during the day. She ultimately joked to me that she needed him to help her at her work with others as he was such a good communicator.

"Yeah, no shit. Try and shut him up when he wants to be heard," I added.

But on that first session, after a few of the other "spirits" communicated themselves first, in my ex came. It was an hourlong conversation, holding no doubt whatsoever in my mind it was him. Here was the amazing thing: he wanted to help. There was information he knew was important

for me to have, more so for the kids, so he said. I have to admit it was eerie at first hearing what I knew were his words coming from the sight and voice of my medium. I was cautious and recorded the exchange for notes to go over later as he seemed to have some very important warnings for us and revealed locations of things we needed.

That first visit did not come without incredible emotion, as I had thought it might. On his part, my ex was very choked up and unable to, essentially, get a grip at first. I kept his info and endeavored to follow up on it all once I returned home. My son joined me; he and I were the spy kings in the whole episodic adventure with my ex. Believe me it was always very complicated. Plus, my son believed in this as much as I did. We didn't find what we were told to look for, so I decided I now had important questions for my husband. Off I went to see my medium again, the second visit. I also felt like I wanted to finally say my peace.

We went straight to her special room with the lace-covered round table and soft candles and closed the door. Immediately, my ex began to communicate; we did not have to ask. As I said, she met up with him earlier on the run for a coffee and she made sure he knew to answer my questions. But a funny thing happened along the way. My medium, my ex, and I began the session with a bit of letting down the hair, quite a bit of fun and laughter. I was quite at ease with the way the conversation was going, and it reminded

me very much of who my ex had been when I met him and how I knew him best. My medium asked me why he was sending her a mental picture of Don Johnson in *Miami Vice* and I nearly fell off my chair. Yes, that was exactly the way he dressed and looked when I met him. She even said, "Wayfarers?" with a big-eyed look to me and I explained that was his signature, those Ray-Bans. He had even put his original ones from the eighties that he always wore, in our family room wall cabinet, on display. Yes, he did answer my questions, and admitted he wanted the attention. And yes, it was him leaving the dimes that the kids and I had been finding randomly for a while, but mostly it was about how sorry he was for it all. He passed on a very important message of love for me.

Truth be told, when it came time for me to have a moment to really speak to him, it was not what I thought it would be. I didn't go up one side of him and down the other. No rehashing of the events of the bad years with him. No anger. Instead, I had a very frank conversation with him about being there for our kids.

"You weren't a father then, so be one now! They need you. Watch over them, help them. Please," I said in a very strong clear voice. Right there and then he made a promise to me he would. And I do believe he kept his word. I spoke to him about what he had meant to me and what our love was. I asked flat out if he thought after all he put me through, I

deserved to be happy. How could he not want that for me? He agreed, I did deserve to, and said he could help with that. I believed at that moment he did truly want that for me. It is hard to explain sometimes, and I did not speak to many people about this for a long time after, but it was a grand movement for me into the future. It was a moment of transformation, of healing, of walking further down a new path. He shared with me that I had not yet met the one that was going to be important. I believed him.

I did see my medium again after that, the door had opened and there are always things we really want to know, aren't there? I always think it's kind of like cheating when you get certain information about the future. My sessions became almost two hours long eventually and there were discussions with quite a few family from the past, even my grandfather that passed away when I was a teenager. I didn't know him as well as I would have liked to, being isolated in that desert for most of the years before his death. What I do remember of him, quite literally, was as Salt of The Earth. He was a hardworking man who took care of his family, always kind and generous to us grandkids. He lived simply in the small house he had built with Grammy and their five kids.

My grandfather gave my medium one image when we asked about love in the future for me. It was a pair of solid brown shoes. She asked me why he was pointing at the shoes. I knew they were his.

"Fill the shoes?" she suddenly asked.

"Yes!" I laughed as I realized immediately what the message meant.

Fill his shoes, find someone who fills his shoes. I promised right then and there I would not just "settle." And I kept my word.

Those initial meetings with my medium led me to bring my son to her. I left him there in that special room at the round table. My ex was already there when my son walked into that room. They closed the door and I waited in the living room. For almost an hour, my son had a very deep and very real conversation with his father, one that gave him absolutely no doubt who he was talking to. On the mostly silent drive back, my son did exclaim to me that he always thought this kind of thing was real, but holy shit how did you not believe now after this? There had been things my son asked his dad for advice on, things he desperately wanted to know, things he had wished he had his father to talk with about. It was such an emotionally charged time for my son as I could only imagine. They had called me in at the end and there was my son and my medium and a very large box of tissues on the table and I knew. They then tried to explain what had transpired, to have me help clarify, and I just simply smiled and said a silent thank you to my husband.

He had done exactly what I had asked him to do—be a father.

ON HOMES
AND LOVE

I STOOD ON THE DRIVEWAY OF MY COTTAGE AND gazed up at the lovely home. To the side was a garage with a spacious loft above that I had designed, proudly, a campy retro California beach house to be specific. I had gone through piles and piles of photos on a site designed for this, showing lofts with bedrooms and kitchenettes, as this was. It was wonderful to do but so hard to choose or narrow it down as I loved them all so much, so I settled on working with a theme. The loft was my pride and joy and turned out very well. Bright and airy with custom cabinets, super cool furniture I sourced dedicatedly and the nicest well-fitting lighting, and on. The builder in town I chose was used to doing some high-end work, but he challenged me on a few issues; he was just not sure. He didn't know who he was dealing with. End result was pretty flippin'

cool. If I do say so myself. The builder ended up quite in awe at how it had all turned out.

The inside of the main cottage definitely needed a lot of work. It was dogged and out of date and needed quite a bit of TLC. But I waited to do that work, all in good time. Instead, I had chosen to do the whole exterior. Tons of yard planning and work went into turning it into a pretty space and a veritable playground. I had expansive lawns with a variety of wildflowers sprinkled about, a sand pit for a badminton or volleyball net, and mini basketball court with one hoop. There were plenty of water toys like kayaks and enormous garish blow-up floaty things, and a very long lovely beachfront. I was just so proud of it.

As I stood on the driveway on that lovely sunny afternoon, I spoke out loud.

"You know, I could live here. I could sell the city home and just live here and maybe still have something south," I said to myself.

I jolted back a bit and looked around and behind me. Not to see if anyone saw me talking to myself, but if anyone actually heard me say it. Suddenly, a memory floated in of something my sister had said to me recently, something about having "plenty of rooms" to choose from. The words were followed by something about "with just me." I literally

exploded into a realization. Then it sank into me, just sank. I didn't move, just stood very still and let my mind wrap itself around that. Was it true? Is that what I had done, create so many spaces and so many rooms to "be in?"

That wishful, wistful, little nine-year-old came bubbling up to the surface. She was crowded in a small motel room with three other siblings, on the floor dreaming of having her own luxurious bedroom. Just like the ones I had, and had plenty of. My mind wanted to count exactly how many rooms I had in total between the three places I occupied, but I pushed that heavy task aside. Everyone always said there were three things that I could be counted on in my homes whenever they stayed over: the best cheeses, the nicest hand soaps, and really great beds. My bedrooms were so comfortable and spacious (there are only King beds in my own bedrooms), bright and laid out 'just so' with beautiful linens and blankets. It was true. All of it.

The 'city home' was my greatest find. It was my Me House. I had been so happy there and so productive and settled. I have to be productive; it gives me purpose, it fills my heart especially since it is about helping others. But that moment on the driveway, that memory of a little girl I hadn't thought of in a great while, that was the beginning of what was coming into fruition for me. The happier I was and the more fulfilled I was in my work, the home was not my "achievement," nor the true fuel for pride. For me

to say the house could go, well, that seriously startled me. It didn't mean I was going to sell it or had any plans to, it just meant I could if I wanted to. This was huge.

Later that month, I was in the Me House on the phone with a man I was seeing who had not been to my house yet. He was about to.

"It's just a house, it doesn't define me," I said to him.

Incredulously, I just stared at the phone. It was out of context to our conversation, and it seemed to shock me to hear myself blurt out those words. After the call, I looked around at all the ways I had turned the house into my lovely special one. The furniture, the big gorgeous kitchen, my bedroom at the back surrounded by plenty of windows looking out at green, it all suddenly looked different to me somehow. I was not able to clearly define how. I felt a shift, ever so subtle, the beginning of an understanding, one that my mind wanted to put away on the shelf until I could really look at it. Which is what I did. I did not want to ponder it that day, I wanted to let it have some space inside me and when the time was right, I would really look at it head on.

Being that completely open and vulnerable was just not in my makeup. Helping others, not me getting it, was how my life went. Being so strong and not showing weakness

in moments when others needed me was the norm. Thinking I had my life where it needed to be was making a monumental shift. Validation of my worth, my value, was going to come from somewhere other than what I owned or how successful I was. Love and peace were going to come for me. Peace from myself, then love from someone very special.

A colorful, hand-carved wooden rooster is the only thing I have from my mother, and it has a particular special meaning to me. One day, my ex-husband tried to destroy it and left it for ruin when he threw it into the yard from the front door of our house. The rooster was rescued, glued back together, and today it is always in my personal or private space. You can see the cracks, its scars. Some are hard to see, but they are there, while it stands tall in its place.

Over the years, I had set to the task of helping others move forward in their lives. I had happily taken on the challenge of helping one of my sisters, in building her dream. I helped her with what she always wanted to do, open a cafe and bakery. I had much to offer her business-wise. With her hard work and dedication, it did very well. I had helped both my kids through the very tough times with their dad, trying to assimilate into a life without him, and get through the good old-fashioned trials and tribulations with school and friends. Then it was time to leave them

be as well; it was time to focus on my own life. Freedom 55? Oh, honey, you have no idea.

I worked on the projects I loved. Opportunities came out of my books and the few speaking engagements they earned. Some went well, others went by the wayside. That was okay, I was also "learning from." I still had great energy and verve and I knew too well the value of life, so the ones that didn't go well were not really of consequence. There were people along the way that wanted to take from me, or actually had taken advantage of me in some way. I didn't sit around too long and feel bad about it. But I knew these things happened on my quest for a kind of love they could provide, and some of them had gotten through. Not for long mind you, I was in the "advanced class," but they left a mark.

Not long after those fateful moments on the driveway, that phone call, and my large moments of visibility, life looked different. My things were just "things." I met a very sweet man who came into my life at what felt like just the right time. The universe has a way of doing that, doesn't it? I am pretty hooked on this one, honorable and sexy and sweet. Or maybe I just see that. Isn't that the way it's supposed to feel when it's right? He is a hardworking man with great values, Salt of The Earth you might say. He and I are taking our time with this, and it's conjuring up some pretty good feelings.

I received a nice note from my medium one day, a few months into my relationship with Mr. Wonderful. She said my ex had come to her and relayed a message for me about moving on. Reaching higher levels for himself was necessary for his own peace, and it included disengaging himself from me. He would still be with the kids and guiding as best as he could, but he needed to leave me in order for me to have a healthy relationship. It was not strange to hear this; I had felt the shift in that around the same time. I hardly felt his presence where I had before.

Feeling connected to my husband had been going on for a while. He was always in a song that suddenly came on the radio, or a memory would pop up in a burst, and there I'd be smiling or laughing and suddenly talking to him. His message to my medium that night also said to just trust and believe and let go. He told me to step over the threshold and not look back. In the best way, she explained why this was necessary for the both of us. That night, I stretched out into my big comfy bed, closed my eyes and created the image of the threshold. I took my time staring at it and the happiness that was clearly on the other side. With a very good long look over my shoulder first, mentally I crossed over it. I said goodbye and made a promise to myself. And I never looked back.

My personal relationship with this new man just keeps getting better all the time. I am fully in it as myself, and

my heart feels as if it's expanding as our time unfolds as it naturally should. It is a wonderful feeling and not a day goes by that I don't say something like, "Yes, Virginia, there is a Santa Claus," or send a silent thank you to the Universe for him. He lives a simple, yet very solid life in a tidy little house where I love to visit and spend hours.

And my homes, my houses just aren't as important anymore. Absolutely they are special and lovely and very me. There will always be fresh flowers in the house, good smells coming from the kitchen and pretty linens, but it doesn't matter what house that's in because wherever it is, it's "home." A friend once said to me he would have three nice places if he could afford it. Yes, but they don't "have to be," not for the Right Kind of Love.

ACKNOWLEDGMENTS

THIS BOOK WOULD NOT HAVE COME ABOUT IF IT weren't for some very special people in my life, from many years ago to now. You are not forgotten, those that made an impact on a little girl's life, a young married woman's, and a strong successful 'older' one's. I carry you in my heart always. Yes, Grandma Rose, we do what we have to do. I know you and Ralph are smiling down from above.

First, a great thank you from the bottom of my heart to Philip McKernan, you tough son of a bitch, for all the beautiful work you put me through uncovering my truth and finding my BraveSoul. I am forever grateful. To every courageous person who gave their One Last Talk, I give this to you, as my One Last Book.

To the whole Scribe team, you never cease to astonish me with your gift of "seeing" and your strong sense of compas-

sion. Emily Gindlesparger and Miles Rote, you rock. You, too, Hal. To Zubeda, my lovely and strong accountability partner, may you fulfill your journey as well, thanks for cheering and making me proud.

To my kids, we never give up on "us," do we? To Andy and Mikey for sharing their stories first, in bravery. My courage to do this came from you.

A very special thank you to Grammy, for always standing beside me in Spirit these last few years of discovering. Wish you were still here.

And a humble thank you to Dwayne, for making me want to love again.

ABOUT THE AUTHOR

SHARI MOSS splits her time between a home near Toronto and a magical "unperfect" place in a small northern town on the lake. An author, entrepreneur, executive film producer, and adventurous warrior, Shari is currently launching her first children's book, *The Marshmallow Kids*, a picture book to help children with the challenge of making friends when moving often.

Her adult kids now leave her more time for her other favorite pursuits: writing, golfing, world travel, and cycling. Her greatest fulfillment comes from helping others in ways she once needed herself.

CPSIA information can be obtained
at www.ICGtesting.com
Printed in the USA
LVHW091934210321
682020LV00017B/796/J